TrashOrigami

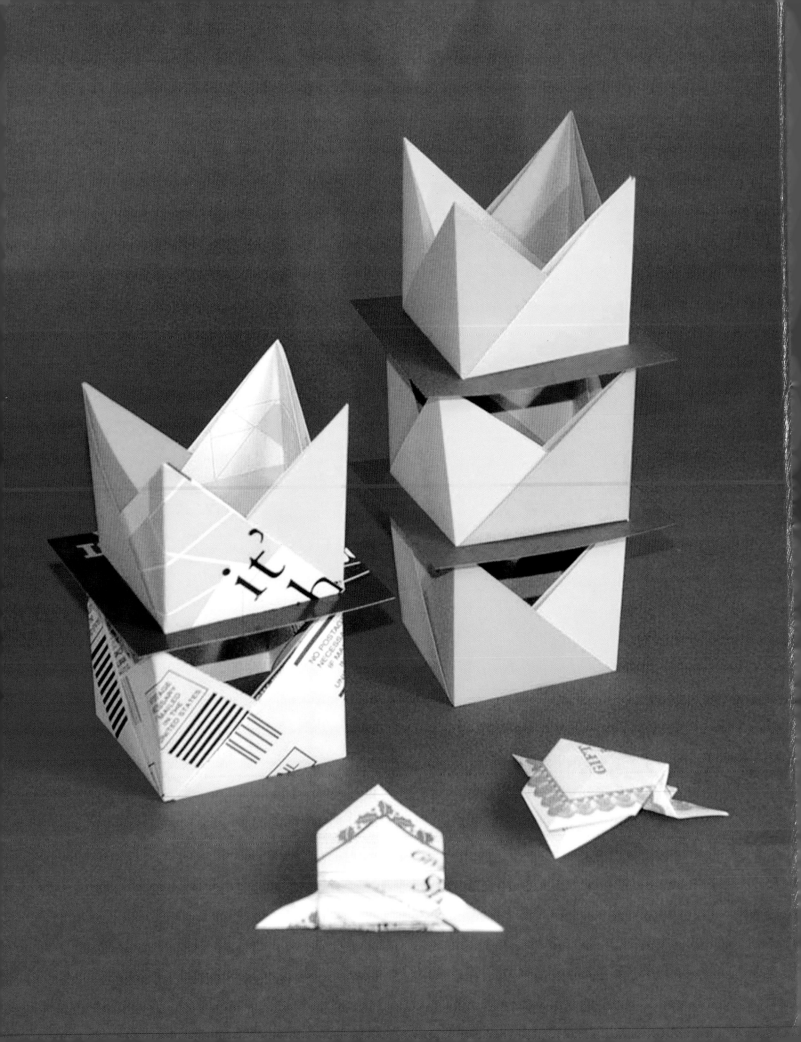

Trash Origami

25 Exciting Paper Models You Can Make with Recycled Trash

MICHAEL G. LAFOSSE
and
RICHARD L. ALEXANDER

TUTTLE Publishing

Tokyo | Rutland, Vermont | Singapore

THE TUTTLE STORY:
"BOOKS TO SPAN THE EAST AND WEST"

Many people are surprised to learn that the world's leading publisher of books on Asia had humble beginnings in the tiny American state of Vermont. The company's founder, Charles E. Tuttle, belonged to a New England family steeped in publishing.

Immediately after WW II, Tuttle served in Tokyo under General Douglas MacArthur and was tasked with reviving the Japanese publishing industry. He later founded the Charles E. Tuttle Publishing Company, which thrives today as one of the world's leading independent publishers.

Though a westerner, Tuttle was hugely instrumental in bringing a knowledge of Japan and Asia to a world hungry for information about the East. By the time of his death in 1993, Tuttle had published over 6,000 books on Asian culture, history and art—a legacy honored by the Japanese emperor with the "Order of the Sacred Treasure," the highest tribute Japan can bestow upon a non-Japanese.

With a backlist of 1,500 titles, Tuttle Publishing is more active today than at any time in its past—inspired by Charles Tuttle's core mission to publish fine books to span the East and West and provide a greater understanding of each.

Published by Tuttle Publishing,
an imprint of Periplus Editions (HK) Ltd.

www.tuttlepublishing.com

Library of Congress Cataloging-in-Publication Data

LaFosse, Michael G.
 Trash origami : 25 paper folding art projects reusing everyday materials / Michael G. LaFosse & Richard L. Alexander.
 p. cm.
 ISBN 978-0-8048-4135-1 (hardcover)
1. Origami. 2. Salvage (Waste, etc.) I. Alexander, Richard L., 1953- II. Title.
 TT870.L2373 2010
 736'.982--dc22
 2010002942

ISBN 978-4-8053-1352-7
First edition
19 18 17 16 15 5 4 3 2 1 1502CP

Printed in Singapore

Distributed by

North America, Latin America & Europe
Tuttle Publishing
364 Innovation Drive
North Clarendon,
VT 05759-9436 U.S.A.
Tel: 1 (802) 773-8930
Fax: 1 (802) 773-6993
info@tuttlepublishing.com
www.tuttlepublishing.com

Japan
Tuttle Publishing
Yaekari Building, 3rd Floor
5-4-12 Osaki, Shinagawa-ku
Tokyo 141 0032
Tel: (81) 3 5437-0171
Fax: (81) 3 5437-0755
sales@tuttle.co.jp
www.tuttle.co.jp

Asia Pacific
Berkeley Books Pte. Ltd.
61 Tai Seng Avenue #02-12
Singapore 534167
Tel: (65) 6280-1330
Fax: (65) 6280-6290
inquiries@periplus.com.sg
www.periplus.com

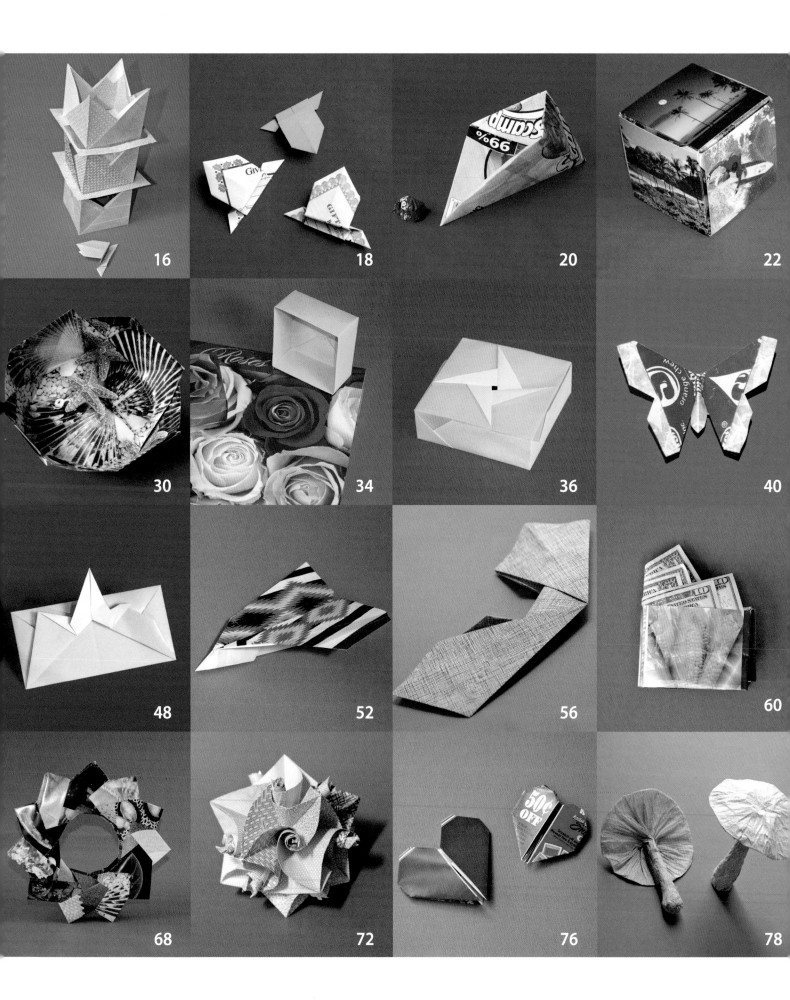

16

18

20

22

30

34

36

40

48

52

56

60

68

72

76

78

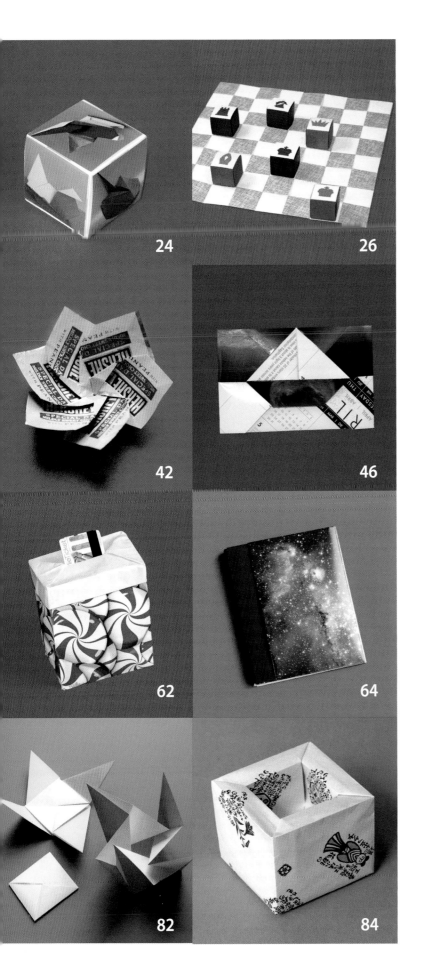

24 26

42 46

62 64

82 84

CONTENTS

INTRODUCTION

We all discard materials that could provide a rich bounty of possibilities to the origami artist, if given the chance. In fact, trash to most is free paper to the origami artist! Which pieces of "trash" can be, or should be repurposed by folding? Which origami models are appropriate for the most typical types of discarded papers and packaging?

Origami artists and authors, Michael G. LaFosse and Richard L. Alexander present 25 origami projects from the Origamido Studio, as well as some created by the world's best paper folding designers. All of these projects are clearly demonstrated in the accompanying DVD. Use "pause," "play," "forward," or "back" controls to view or review any part of a lesson at your own pace. It's like having private origami lessons from a master!

Some of these models were selected for the young folder who may have little or no previous folding experience. Others may appeal to the more experienced or sophisticated folder, making the book wonderful for family get-togethers, home schooling, and other, fun, sharing and teaching opportunities.

Sometimes people who appreciate origami purchase origami books or kits, but get too frustrated by the drawings before completing any of the models. Use the video instructions to better understand what the diagrams mean! In this way, this book and DVD will convert those other, unused origami books into newfound fun. So many of our origami video customers have thanked us for helping their dusty, older, unused or underused origami books and kits come alive.

Most schools have less money to purchase art supplies than they had in previous years, but there may be more to learn from reusing materials we would otherwise throw away without a second thought. Get ready to look at the contents of your wastebaskets and recycling bins with a different sensibility. There's hours of fun and creative potential represented by FREE PAPER! Fold your trash into a treasure of pleasure!

RAW MATERIALS

Here we have listed a few of the things that come to mind, and we know you will soon find others. After folding a few of the projects in this book, you will soon be looking at these materials much differently. You will know where to trim the wrapper, photo or bag to correctly position a specific image, symbol, or color to appear in the desired place on the folded model.

Brochures. Quickly outdated, glossy colorful brochures can be plentiful. Get to know your local printers, who often discard overruns and misprints.

Business cards. People move around in their companies, changing positions as better opportunities become available. Unused business cards often contain attractive colors and logos. Some multi-piece origami models from business cards require thousands for their construction.

Butcher paper. Inexpensive, white roll stock is versatile for large origami projects. Warehouse clubs often sell huge rolls of different widths.

Calendars. Large, colorful, and glossy, these nearly square images work great for simple folds. They quickly become popcorn bowls for your next movie night, or attractive boxes for gifts of cookies.

Candy wrappers. As if candy needed to be wrapped to make it more appealing! Many wrappers are printed in multi-colors, and even shiny, colorful foils. They make great butterflies and flowers, and often lend a sweet or chocolaty aroma to your bouquet.

Card stock. Heavier papers, such as bristol board, and other cover stocks make sturdy models if the folding is not too complicated. Choose these papers for projects that require body or spring.

Cash register receipts. Giving a gift that might not be the right size or color? Make sure your fussy recipient does not get hassled when they try to exchange it for another by including the register receipt as a clever note-fold. Register tapes want to curl, and with a little help, can be quite an attractive and handy addition to the wrapping, just-in-case they are needed.

Copier bond/printer paper. Computers were supposed to make our lives paperless, but even when we do need to print an important email, it seems like the last word or two requires a new sheet. Most of the time, you can re-feed the blank sheet into your printer, but when useless printed sheets gather unused, it is time to get some enjoyment by folding them before their trip to the recycle bin.

Corrugated cardboard. There are so many grades and types of corrugated paper stock, it is difficult to use them all. Several people have written books of their furniture designed from folded, cut, and laminated cardboard. We like to reuse our larger boxes by cutting them down, making smaller containers and shipping cartons that feature the same type of folding, tabs, and locking mechanisms found in clever packaging you can buy at the shipping store. Our favorite is white corrugated stock, since it can also be used

to stiffen larger folded mobiles without showing through the other paper (usually water color stock).

Dog food bags. Large pets require large bags of food. Dog food and kitty litter bags are often made of tough, heavy paper stock, and they bear thick, permanent, and colorful coatings. Some bags are multi-layered, and an inner bag may be kraft paper, or perhaps waxed. How many times have we heard Origamido Studio customers complain that they need larger origami paper? When they find large sheets in the stores, they are shocked at the price, yet under their cupboard at home there probably is a steady supply of brightly colored raw material! Just feed your pets regularly, and the bags are yours for the folding.

Fast food wraps. Many fast food restaurants' taco and burger wrappers are perfectly square, and often have attractive designs. One chain features an image of an origami hen! See if you can fold one out of the wrapper by looking carefully at the image.

Fabrics bonded to paper. So called "fabrigami" is quite popular because fabrics come in so many interesting colors and patterns. We use spray adhesive to bond the fabric to a foldable paper, such as a watercolor paper, and then proceed to fold the laminate into large animals,

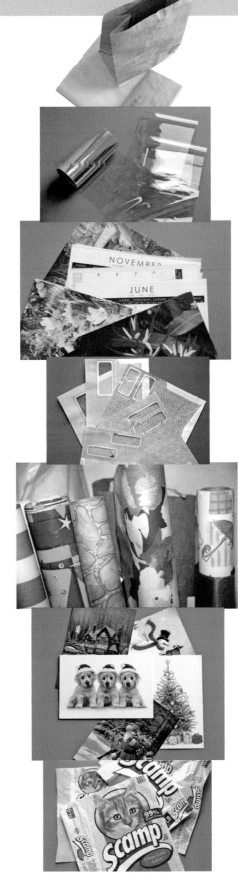

flowers, and even attractive boxes. These projects benefit from inserting pieces of card stock to give larger creations more structural support. Iron-on bonding agents work well too. Heavy watercolor paper may require moistening along the creases first, but when restrained in position and dried these creations will keep their pose for years.

Giftwrap. Rolled or folded, giftwrap is usually overlooked for origami because it is often too flimsy. Although you may want to bond it to butcher paper or watercolor paper with spray adhesive, we find that simply co-folding it with other paper works out quite well.

Glossy Magazines. Editors spend painstaking hours getting their photographs to appear irresistible. Why is it so easy to toss out a work of art, just because we have read it? But perhaps you keep too many magazines because the photos are too beautiful to discard. Invest in a nice paper cutter and start harvesting your favorite photo mag pages. The image that haunted the photographer can find a new audience when you place it on your folded art.

Greeting Cards. We all save them for awhile, but when stacked in a drawer, do they really ever get used or even re-read? This book contains a project that works great with greeting cards cut square. Group the graphics by theme, and enjoy your favorite cards "reincardnated" so to speak, into wonderful and colorful, hanging kusadama flower balls.

Grocery bags. When asked, "paper or plastic?" if we don't have our canvas bags, we always say "PAPER please!" Good old kraft paper bags are so versatile and strong, suitable for many projects. The paper is heavy enough to "wet fold," and takes acrylic colors, finger paints, markers or charcoal beautifully.

Gum wrappers. What parent or grandparent, back as a school child, does not remember making gum wrapper chains? Granted, many gum packages are wrapped differently today, but the time-honored stick of gum still exists, and the colorful wrappers of our youth can still be turned into artfully interlocked, zig-zagged chains, rings, and other things. Grab a kid and get nostalgic!

Hamburger patty paper. Your local restaurant supplier has boxes of perfectly square, white origami paper called patty paper. In our area, 1,000 sheets can cost as little as $5.00 The patty paper is translucent, due to a grease-resistant coating, and it folds beautifully.

Index cards. Either 3 x 5 or 4 x 6, these ubiquitous office supplies now come in dozens of colors: primary, pastel—even neon! If you use them for organizing your thoughts, why toss them when you are done? They lend themselves to a host of creative origami projects, and if you are not going to use them, save them up for a child genius in the neighborhood.

Junk mail. This category is too broad to consider here, but we look at stuff in the mailbox as unfolded origami. Pay special attention to unique colors, textures, and patterns.

Kitchen foil. Adding a layer of aluminum foil to otherwise flimsy folding material often does the trick, making it suitable for a wide variety of folded projects. The foil can be applied with spray adhesive, or simply co-folded until there are enough folds to keep the composite together. The foil adds a sculptability to the model, and enables you to add semi-permanent forms and shaping not possible without it. Some materials, such as translucent films and tissues allow the reflective foil to shine through.

Maps. Old road maps have the most interesting patterns and colors. The places conjure memories of special visits, picnics,

camping trips, or even getting lost! Incorporate them into origami keepsakes or thank-you notes, since paper maps may be a thing of the past very soon.

Metro tickets. Perhaps no other flat object, with the exception of paper currency, is so fiddled-with. Our studio was presented with a marvelous miniature motorcycle consisting of interlocked, folded, yellow, magnetic metro cards, folded by a student we met at an origami conference in Paris.

Napkins. Here is the most UNfolded origami in existence. Every napkin is folded to be unfolded, and many books have been written to impart the state of the art on the hospitality inclined. What a pleasant surprise to enter a dining room adorned with crisply starched and folded fancy napkins.

Letterhead. How much did you spend designing the perfect fonts and logos for your fancy letterhead? You probably even sprang for the more expensive, higher quality papers. Now you are left with boxes of it, thanks to a change in address or phone number. Incorporate your brand into a wide variety of objects that use this resource in a more casual way. Paper airplanes that feature your company name on the wing work great at a bazaar or trade show, and the kids will scramble for them. Why not fold them into clever locking envelope folds? How about that four-piece box lid? Make another slightly larger, and you have a two-piece box, announcing your company name 8 times!

Magazines. National Geographic and other colorful photo magazines have luscious layouts. Even the photos in the ads are spectacular. Not everybody can collect every issue, but the photography is so stunning, these issues long for afterlife. In the 1970s there was a fad of folding every page in a way to produce interesting doorstops or Christmas trees. The size is perfect for most origami projects, and your paper cutter will pay for itself by harvesting the most impressive photographic images for rebirth as butterflies, boxes, or birds.

Memo notes. Colorful cubes of 3 to 4 inch (7.5 to 10 cm) square-cut memo notes come in handy acrylic holders from your local office supply store. The non-sticky type are less expensive, and are more useful for reincarnation as modular origami after their usefulness as handy reminders has passed.

Newspapers. Not just for party hats, newspapers provide practice paper for large origami creations. The fibers are short and weak, so supercomplex models need not subscribe, but newspaper comics may be perfect for kids' gift-wraps and piñatas.

Packing tissue. The shirt is ugly, but the tissue in the shirt box is still useful, so muster up a cheerful "Thank You!" and work up a wonderful crumple-crimp design inspired by Le Anarchistes paperfolders in France. Crumpling tissue makes organic origami otherworldly. The Floderer Mushroom design in this book is just the start. Large sheets of thin paper become wonderful hats, trees, urchins, and anemones.

Paper bags and sacks. These sturdy mainstays already have much of the folding already done. Available in many colors and sizes, the ones from heavier paper are suitable for wet folding with just a spritz of moisture from your plant sprayer. Use your creativity to enhance what Mother Factory has given you, to create decorative and inventive variants of the ultimate utilitarian object.

Paper currency. If you have ever spent any money without folding it first, you have not gotten full enjoyment from having it! U.S. dollar bills are tough, high quality papers. Thousands of projects have been folded from dollar bills, thanks to the fact that we often have an idea when we have nothing else handy to fold. Gifts or tips, decorations for table or tree, these greenbacks become cherished keepsakes. Many dollar bill folds are quite involved, and can take considerable time and practice, but if you want to start with a series of simple and fun projects, obtain the "*Money Origami Kit*" from this publisher, and start enjoying your hard-earned cash. The next time Aunt Mildred visits Egypt, ask for some local paper cash. Many countries have bills that cost much less than a buck, and the variety of colors, graphics, and materials will wow you.

Patterned security envelopes. These intricate designs, intended to keep nosey eyes from reading the enclosed financial documents, come in a wide variety of colors and patterns. One dear friend and

Origamido Studio artist prefers these patterns for his unique origami jewelry. The fine patterns complement the small birds and flowers of his earrings. At first, people will admire the paper, knowing that they have seen it before... somewhere. Very few people realize that the jewelry is crafted from Wall St. correspondence.

Photographs. Too many to keep, too good to throw away, we often take or print multiple photos of the same subject. The colors are interesting and the paper is durable, so why not incorporate replicate photos into folded keepsakes? Holiday ornaments can be folded to place the image (which may have been too small for the photograph) into the center of the ornament (where it is now of a perfect size). Fido is now featured in the center of an ornament star!

Plastic sheets, films, and laminates. So many colors, textures, patterns, of today's myriad of foldable materials! Holographic, metalized, scintered, pressed and embossed, laminated, fused, or infused with perfumes, nobody can keep up with advances in plastic sheet, film, and laminate stocks. Experimentation is the operative word. Many will not hold a fold, and are likely to be useless unless bonded to a crease-loving substance. The good news is that many are durable and attractive, so why not reuse them?

Playing cards. After they are all played out, playing cards can have a new life as game pieces, ornaments, cubes, boxes, or rings. The stiffness makes great jumping frogs, and the ornate backing lends itself to inside-out (color-change) models.

Play money. Has your old Monopoly set been retired? Recycle that game cash with origami. Plenty of inexpensive funny money from ads, coupons, or even the dollar store will keep the kids in cash for money folds.

Polyethylene sheets. Tough and durable, poly and acrylic sheet stocks are everywhere in our packaging today. Many are transparent or translucent, so make perfect outer panels for the photo cube project in this book.

Postcards. Let the memories linger a little longer! Who sees them hidden in a drawer? Put then together and what have you got? A three-dimensional atlas of travel memories, and an attractive way to display the works of talented photographers and artists.

Rack cards. Fold up those brochure cards from your vacation to make coasters, rings, cubes, or boxes. They will remind you of that jam-packed vacation when you couldn't relax fast enough to get everything in.

Reader Return Cards. Get back at these pesky subscription offers that drop out as you flip through your favorite mags. The heavier cardstock makes sturdy cubes, and the banded barcodes become strikingly integrated stripes in your final form.

Shipping paper. Kraft paper provides the poor man's backing to numerous fabrigami, and giftwrap creations. Heat set, spray adhesive, or tacky glue is all you need to impart the foldability of shipping paper to other, less cooperative materials. Best of all, it comes big!

Snack bags. The technology engineered into today's potato chip bag is astounding. Tough and colorful, glossy and mirrored, these masters of crisp-keeping get tossed just because they may be a little greasy. Next time you wash your spoon and cup, cut the empty chip bag and let the detergent get the grease off. Wipe it dry, and you've got a durable new wallet after just a few folds.

Soup, and other can labels. So the kids are into folding dollar bills, but they are driving you crazy going into your wallet... Here's a solution! The veritable Campbell's Tomato Soup can label comes off the can easily, and you choose where to slit it to place the colors and patterns where you want them to be on virtually any dollar bill fold. That's right! The proportion of the can label is so close to the proportion of the dollar bill that the can label can be used for thousands of patterns designed for the buck.

Tyvek.™ Non-woven polyolefin construction housewrap is available from many different companies and suppliers, and it is all tough and versatile. This material repels liquids, yet allows moisture vapor to breathe through. Origami artist and performer, Jeremy Shafer, of Berkeley, CA uses large sheets of housewrap for his street performance props. Snag those white scraps from the local building project, and create bigger, better, tougher origami creations.

Waxed paper. Remember wax paper? Long before plastic wrap, everything got the wp treatment. Inexpensive, translucent, heat activated bonding... wax paper has it all. Use a clothes iron (on the low heat setting) to bond it to fabrics. Imbed colorful, flat objects between layers. Fold floating boats or flowers, and liberate your wishes or problems in an origami offering.

MAKING SQUARES

Neat origami often begins with a perfect square. If the first diagonal crease does not hit the corners when opposite angles are aligned, you haven't got a square. If opposite edges line up, but the ends don't, you haven't got a square. If only seven people show up at the barn dance... (you got it) you haven't got a square! So how do you make a square? Here are six methods:

1. Cheat. Use the perfectly square cardboard packer, left over from your last pack of origami paper, as a template. Trim the new stock along the edge of the cardboard with the help of an razor-sharp knife and a metal straight edge. (Kids should draw a pencil line around the template and use safety scissors.)

2. Derive the largest square. Trim one edge perfectly straight, and then fold one end of the edge back on itself. Ta da! You have just constructed a 90-degree angle along the fold. Trace, fold, or cut, and you are well along the path to making a perfect square. Need more help? Transfer that folded line to one edge, keeping the initial, cut edges perfectly aligned, and you can trim the paper at right angles to the original edge. Open.

3. Make it smaller? Now swing either adjacent edge to the first edge, and determine the size of your desired square with a scissor snip. Open. Lay the initial edge to the snip along the base, and trim the new edge. Repeat the process by bringing the excess over at the snip mark, carefully aligning the edges, and trim.

4. Make a series of smaller squares: Fan fold to divide a large piece of stock into the appropriate width, but begin by folding the material in half first, then quarters, then eights, etc.

5. Use a ruler. Perhaps you need a precise dimension of squares for your project. Go ahead and tick off the marks next to a ruler, but first double back the edge so your marks will show when you flip your marked edge back over the stock to transfer the marks to the opposite side of the larger square.

6. Pythagoras. "Three, four, five" is the simplest set of integers to solve his theorem, and the easiest to remember. This works great for very large stock, such as Tyvek™ or sheet plastic. To make your first cut at a perfect 90-degree angle from a straight edge, mark the corner, and just measure up four units and push in a pushpin. Loop a string around the push pin and mark the taut string at five units. Make another mark on the same taut string at eight units (that's the additional three), and pin the last mark back on the corner. Pull the string taut again, and your five-unit mark will now be where you cut to, from the corner, to make a perfect right angle. Folding either perpendicular line on itself will transfer the other perpendicular edge exactly parallel to its original position. Thank you, ancient Greeks!

MAKING SQUARES AND SILVER RECTANGLES

Standardized paper formats, such as US letter, legal, and tabloid, and the "A" series (A4, A5…) common in Europe, Japan, and elsewhere, are among the most common papers entering the world's waste streams. Many of us grew up making simple paper airplanes from these letter-size sheets. For the paper plane enthusiast, letter paper is a staple. You need not prepare the paper in any special way, just begin folding.

As for the pure origami enthusiast, it is the square sheet that is the "gold standard." A square sheet is easy to make from just about any scrap of paper. Simply fold the short edge of a rectangle to match a long edge and cut away the remainder. You will have a usable square for origami projects.

Almost as easy as producing a square by the fold-and-cut method is the method for making a silver rectangle, which is the kind of rectangle that has the same ratio when it is folded in half. The "A" series of letter and printing papers has this characteristic. The silver rectangle is special in that it has many interesting geometric and mathematical properties. Fold a silver rectangle in half, short edge to short edge, and the new, smaller rectangle will also be a silver rectangle!

The following demonstration will show you how to prepare a silver rectangle from US format papers, or just about any non-silver rectangular scrap. You will need a silver rectangle for David Brill's Masu, and you may enjoy making Rona Gurkewitz's fold-bound book from silver rectangles.

For more information about silver rectangles, see page 94.

SQUARES

1. Fold a short edge to match a long edge.

2. Cut along the horizontal short edge.

3. A square sheet ready to fold.

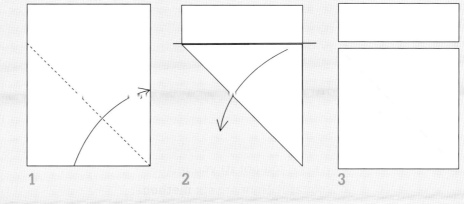

1 2 3

SILVER RECTANGLES

1. Fold the bottom short edge to match the long right edge.

2. Unfold.

3. Fold the long right edge to the crease.

4. The point where the square corner touches the crease indicates where the cut line will be. At that point you will cut along a line parallel to the long left edge. Unfold.

5. A silver rectangle. You will notice that the rectangle contains creases, which you may not wish to show in your origami pieces. You can use this silver rectangle as a template to make clean versions of any size.

6. Lay your silver rectangle template into the upper left corner of your folding paper. Draw a straight line from the upper left to the lower right corner of the silver rectangle. Extend this line to the bottom edge of the paper to be trimmed and make a mark there. Cut parallel to the right edge at this mark.

7. Your clean, enlarged silver rectangle.

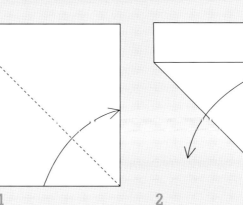
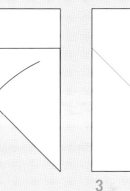
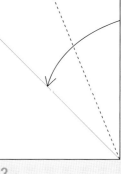

1 2 3

4 5 6

Designed by Michael G. LaFosse

Crowns & Towers Game

I invented this project as a paper folding activity for kindergarten and first grade students. The simple folds are easy to remember, and the motor-control of the fingers, and building skills for the assembly steps are wonderful for young hands and minds. The game developed as I discovered that an element of competition and excitement motivated the students best. This puzzle and game is now ready for all ages. Can you think of your own variations of play? If the four-piece crown is too small for young frog-handlers, make them a larger target by adding more pieces, forming a ring, or even concentric rings!

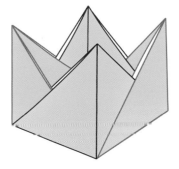

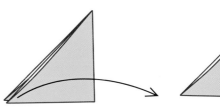

X 4

1. Use memo notes, approximately 3½ inches (9 cm) square, or trim small squares from any scrap paper. All squares must be the same size. Fold in half, diagonally, forming a triangle.

2. Fold the triangle in half, corner to corner.

3. Open the triangle half way, forming a 90 degree angle between the two flaps.

4. You will need four of these elements to build one crown.

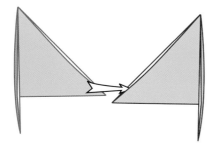

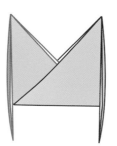

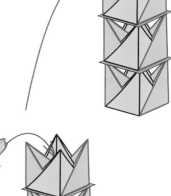

7. Add the other elements in the same manner and you will have a four-point crown.

5. Fit together by inserting the corner flap of one element into the corner flap of another.

6. In this case, notice that the green flap went into the yellow.

8. Build towers by stacking crowns with an unfolded square of paper between each. See how tall a tower you can build before it collapses. Are there other structures that you can build? Have a race to see who can successfully fold and build a three-crown tower first!

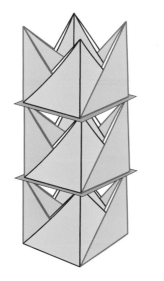

9. Use the jumping frog project to make that game even more challenging: build a crown and try to get a jumping frog to land inside. Only then can you build and add another crown. At each level a frog must jump in before continuing to build. The first to make it to three crowns, with a frog in each, wins!

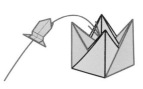

Designed by Michael G. LaFosse

Jumping Frogs

There are many jumping frogs in origami but this one is quick to fold, so the fun starts sooner. Use a 3-to-4 inch (7.5-to-10 cm) square of stiff paper or card to get the best jump. Make use of index cards and those pesky magazine subscription offers. Also try squares cut from cereal boxes, colorful junk mail, and various vacu-package insert cards—frogs don't have to be green: Think of all the colorful varieties of tree frogs and poison-arrow frogs in the Amazon!

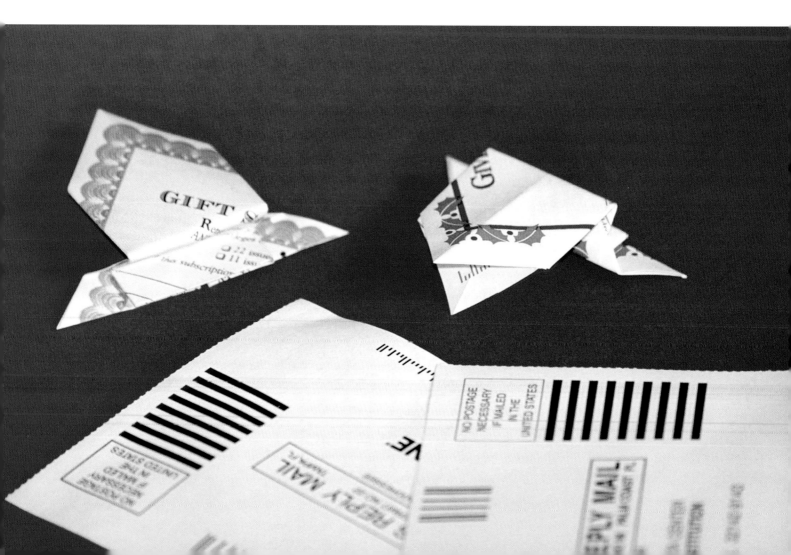

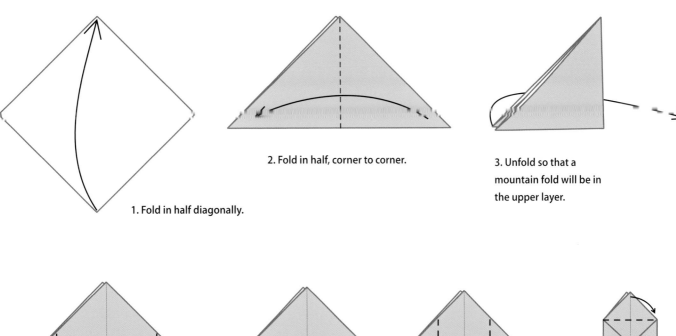

1. Fold in half diagonally.

2. Fold in half, corner to corner.

3. Unfold so that a mountain fold will be in the upper layer.

4. Fold the two bottom corners to meet at the center of the bottom.

5. Turn over.

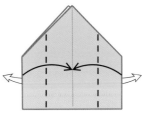

6. Fold the left and right edges to meet at the middle, allowing the corners to come out from behind.

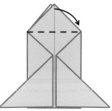

7. Fold the top corner of the first layer down for the mouth.

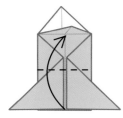

8. Fold the bottom edge up under the mouth.

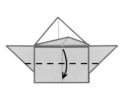

9. Fold the indicated end down but not quite to the bottom edge. Leave a slight gap.

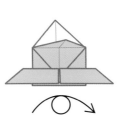

10. Turn over.

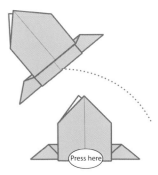

11. The Jumping Frog! Press the hind end to make it jump. Use this jumping frog to play the "Crowns & Towers" game.

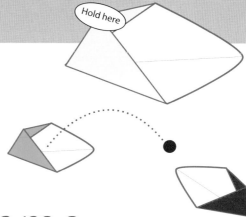

Designed by Michael G. LaFosse and Richard L. Alexander

Scoopy Ball Game

Old newspapers, posters, or gift wrap can quickly be converted into a fun game of "Scoopy Ball!" Richard Alexander designed this game many years ago by converting my page corner bookmark into a scoop. A crumpled ball of paper completes the list of equipment. Much of our packaging is weather resistant, coated paper or plastic, so they make great outdoor games, free fun for all ages!

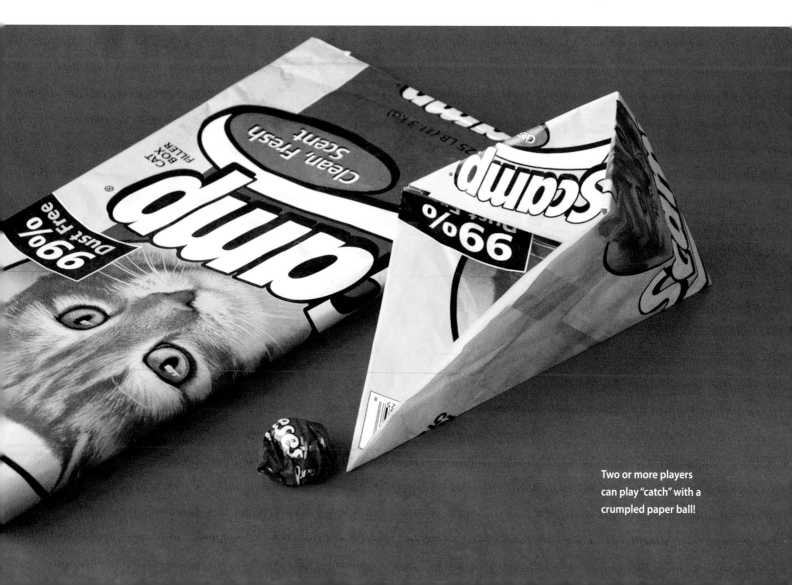

Two or more players can play "catch" with a crumpled paper ball!

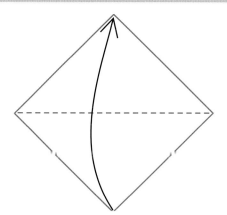

1. Use a square of paper at least 10 inches (25 cm) to a side. Fold in half diagonally, forming a triangle.

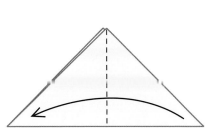

2. Fold the triangle in half, corner to corner.

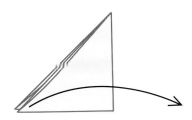

3. Unfold back to the larger triangle.

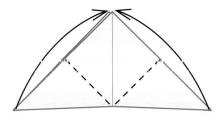

4. Fold the bottom corners up to the top corner.

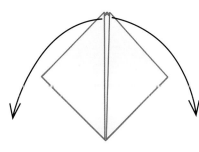

5. Bring the corners back down.

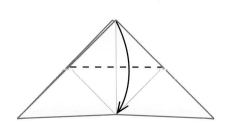

6. Fold the top corner—of the top layer only—down to the middle of the bottom edge.

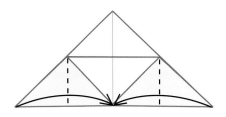

7. Fold the bottom corners to meet at the middle of the bottom edge.

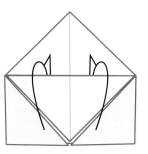

8. Tuck these corners into the pocket, behind the middle flap.

9. Your paper will look like this. This is the bookmark. A small example of this can fit over the corner of a book page to mark its place.

10. Form the scoop by pulling the front layers away from the back layer. Push the side corners together while doing this.

Traditional

Flap Cube Cores & Paneled Cubes

The flap cube core is an old paper folding puzzle. I learned to put finishing panels on the cube from Jeannine Mosely, of Massachusetts, whose working geometric origami is quite remarkable and mathematically complex. The finishing panels make the cube rigid, and if clear panels are used, they can hold inserted materials for display (forming a photo cube). If the cube is to be used as a container, selected panel flaps may be inserted differently (straight in, rather than tucked underneath) to allow easier access to the contents.

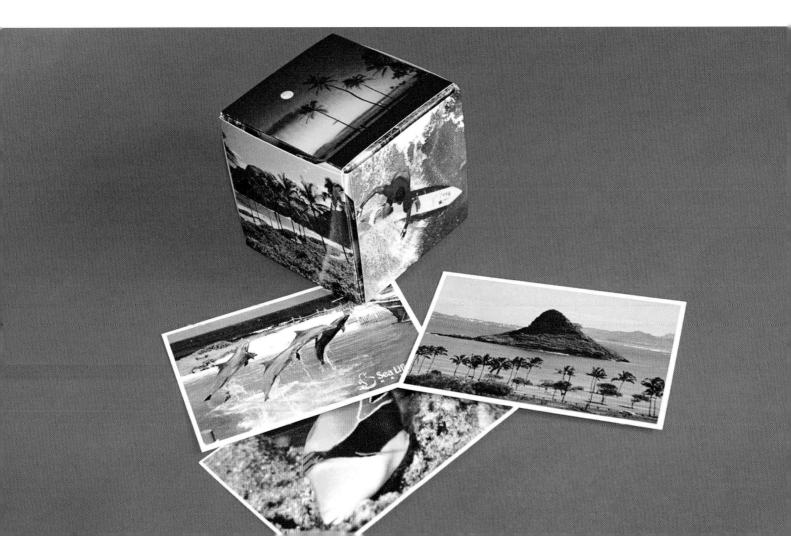

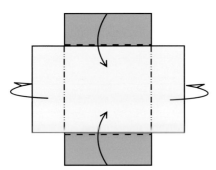

1. Hold two cards at a time, centered and at 90 degrees to each other. Fold the extraneous edges over the sides of each card, making a square tile.

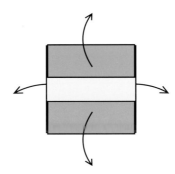

2. Unfold the overlapped edges and separate the cards.

X 3

3. You will have two units of the cube complete. Notice that the flaps are at 90 degrees to the center areas. You will need six units to build one cube, so you need three sets folded.

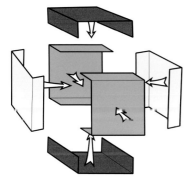

4. Assemble the cube puzzle one element at time. You can see here that opposite cards must be oriented so that all folds are parallel. The card flaps must remain on the outside of the cube. Look ahead at the next drawing to see the solution.

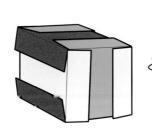

5. The assembled cube.

6. Make the faceplates to finish the outside of the cube by folding two cards at a time, as for the original cube.

7. Unfold and separate.

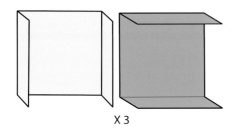

X 3

8. You will need three sets of two to cover the cube faces.

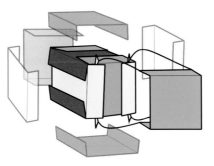

9. The cover cards must be oriented so the flaps of the cover cards can fit behind the flaps on the cube faces. These will lock the cube securely and give it a clean finish.

10. The finished, paneled cube.

Traditional

Photo Cubes

Here's how to turn your Paneled Cube into a Photo Cube to better display your favorite photos. Place cubes throughout your home to bring attention to new photos and give new life to old ones. The cubes are also a great way to display magazine clippings and children's art.

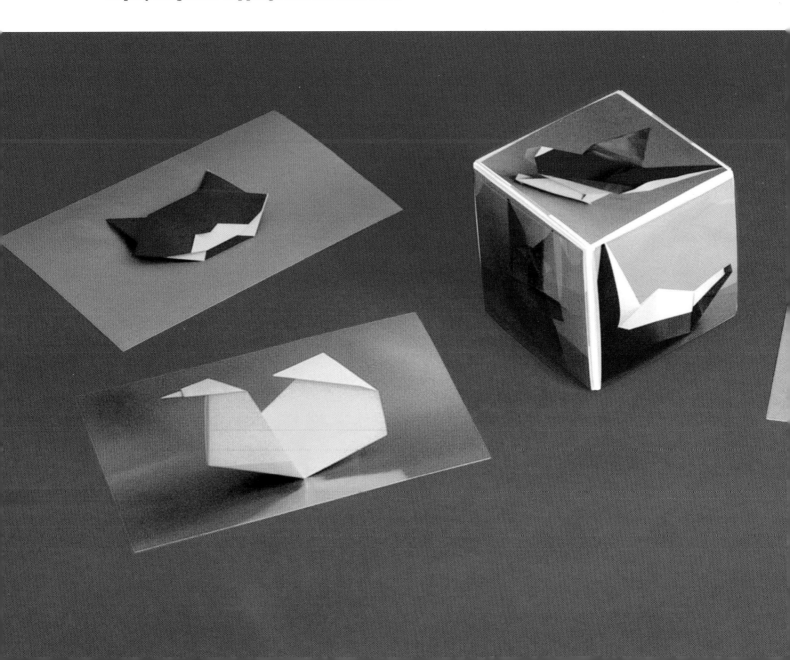

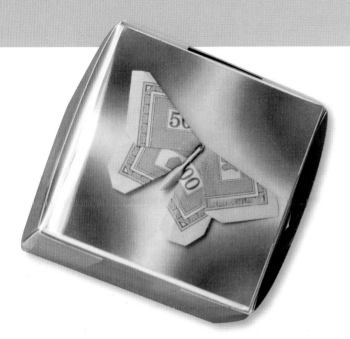

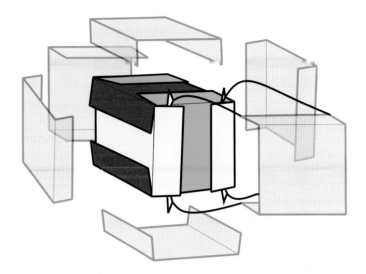

1. Build a cube puzzle of the proper size to hold your photos.
Use clear acetate, or other recycled, stiff plastic sheets,
as cover panels, instead of using paper or cardstock.

2. Slip your photos behind the plastic panels.

Designed by Michael G. LaFosse

Modular Chess & Checkerboard Sets

Play a game of chess or checkers with totally recycled materials! For the board, select paper with one color on one side and a contrasting color on the other. Six-inch (15 cm) squares will make a board that has a 1 ½-inch (4 cm) grid. Since each sheet becomes four spaces, you will need sixteen squares of paper to build one complete, 64-space checkerboard. Reinforce the back of the board with clear shipping tape to make a durable, portable, unique, personalized, roll-up game set. For the pieces, fold and build cubes of the proper size to use with your origami chessboard. Use the paneled cube project from page 22 to fold chess pieces. Build enough cubes for each set of pieces, and then draw or print each piece to signify the ranks on the tops. You can also use real chess or checker pieces on this board, or repurpose colorful bottle caps as game pieces.

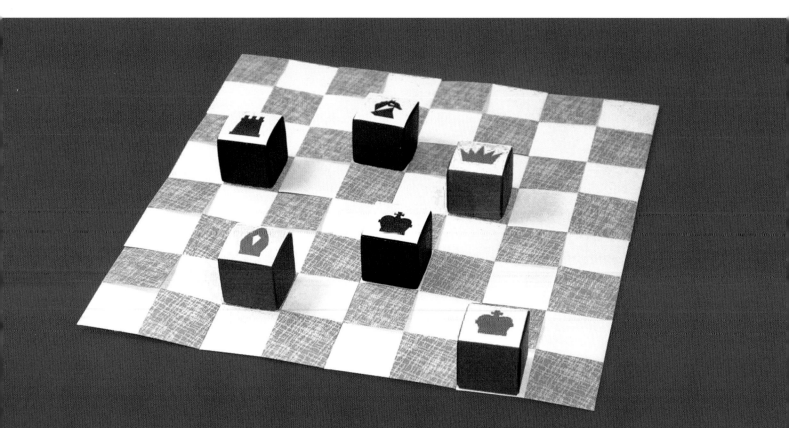

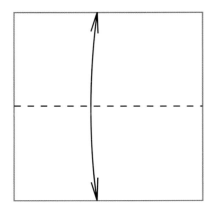

1. Begin with the lighter color facing up. Fold in half, edge to edge. Unfold.

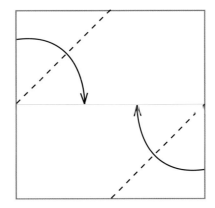

2. Use the center crease as a guide to fold two opposite corners to meet at the center of the paper.

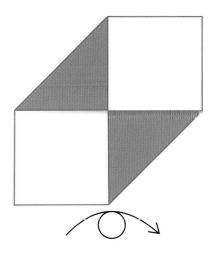

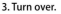

3. Turn over.

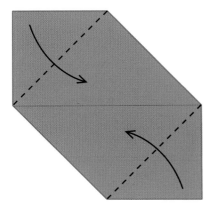

4. Fold the other two corners to meet at the center.

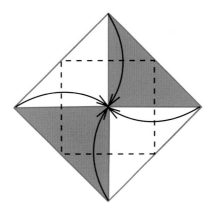

5. Fold each of the new square corners to meet at the center.

6. Move the top and the left corner flaps out. Fold the indicated edges of the left and bottom flaps to the outer edge of the paper. Look ahead at the next step for the shape.

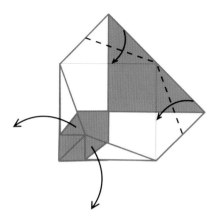

7. Fold the indicated edges of the top and the right flaps to their nearest crease line. Open out the left and the bottom flaps. Again, look ahead at the next step for the shape.

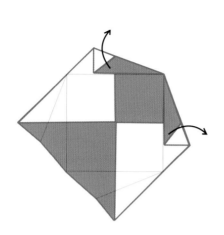

8. Unfold the indicated top and right flaps.

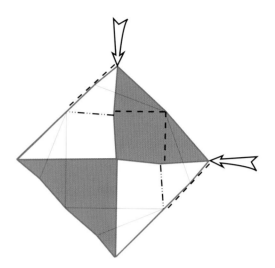

9. One at a time, push the top and the right corners inside the paper. This is an inside-reverse fold action. Look carefully at the mountain and valley fold indications. You are reorganizing the layers of paper to form open pockets.

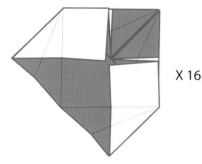

X 16

10. Check the color pattern and the layering carefully. Fold 15 more for a complete set of units.

11. Begin assembly by forming rows of four units. The left side flap of one unit fits into the right side open layers of another.

12. Once they are snug you can lock them together by mountain-folding along the indicated crease. All of the layers, pocket and flap, will be secured.

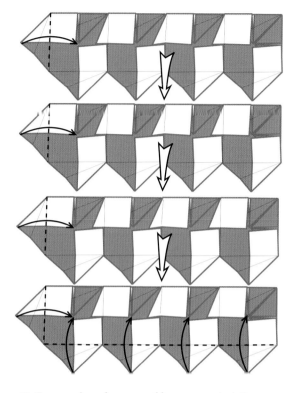

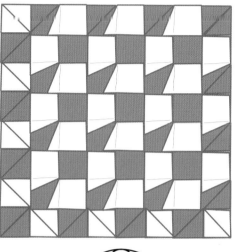

13. Once you have four rows of four you can lock the rows together in the same manner: flaps into pockets, mountain-fold to lock. Fold in the unused flaps at the left and bottom perimeter of the board.

14. The assembly will look like this. Turn over to see the completed board.

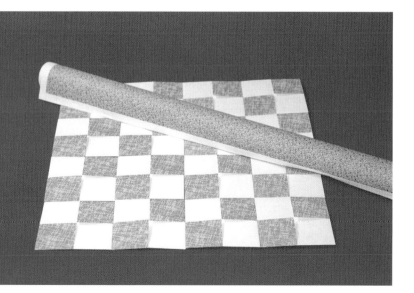

15. The checkerboard!

Designed by Nick Robinson, United Kingdom

Ali's Folded Dish

This is a satisfying dish, indeed! Try a variety of foldable materials, including thin cardstock, old posters, scrapbooker's squares, and certain types of plastics. Nick's design is fun to fold, and quite practical as a popcorn, candy, or snack dish, and it makes an attractive container for potpourri.

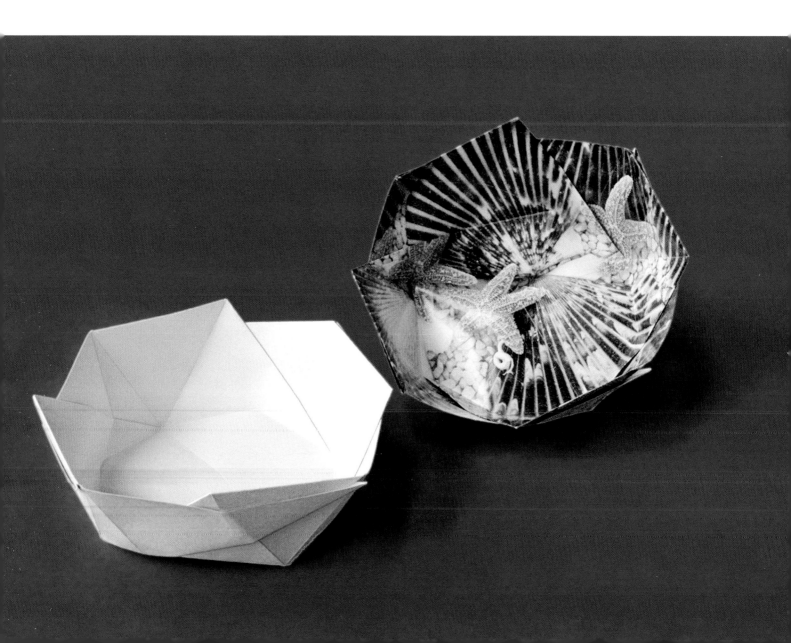

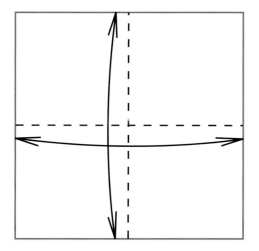

1. Begin with the paper wrong side up. Fold in half edge to edge both ways, unfolding after each.

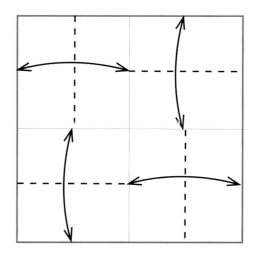

2. You will see that the paper is divided into square quadrants. Fold each quadrant in half, edgewise. Be sure to copy the crease pattern in the drawing. Notice that the bottom left quadrant is horizontally creased while the bottom right is vertical, and so on. You should rotate the paper as you go, for comfort and accuracy.

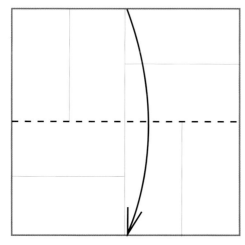

3. Fold the top edge down to meet the bottom edge.

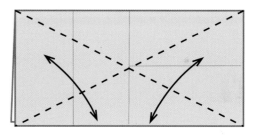

4. Fold the top layer only, diagonally both ways.

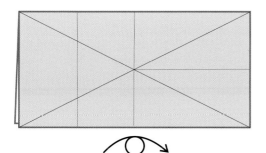

5. Turn the paper over, left to right.

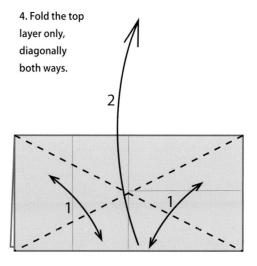

6. (1) Fold this new top layer only, diagonally both ways. (2) Open the paper.

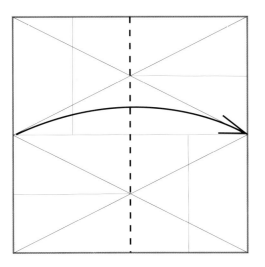

7. Your crease pattern should look like this. Fold in half, left edge to right.

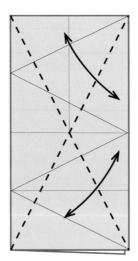

8. Fold the top layer only, diagonally both ways.

9. Turn the paper over.

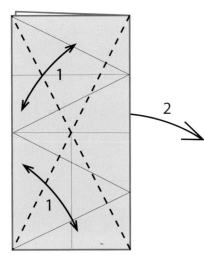

10. (1) Fold the top layer only, diagonally both ways. (2) Open the paper so that the display side faces up.

11. Check your crease pattern to see that it matches the drawing and that no creases are missing.

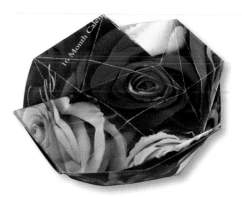

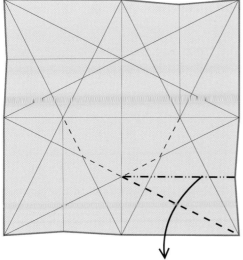

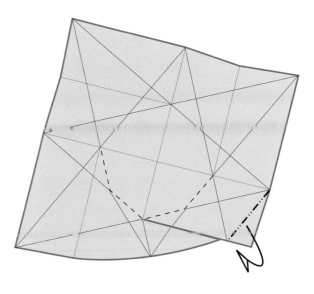

12. Your paper is now programmed to form the bowl! Mountain and valley-fold along the indicated creases, forming a triangular flap that will overlap the edge of the paper.

13. Mountain-fold the corner of the flap over and tuck it behind the outside layer of paper. Look ahead for the outside view.

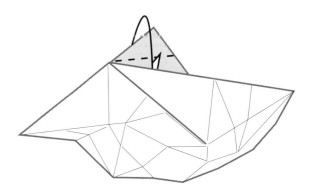

14. Outside view: tuck in the corner flap.

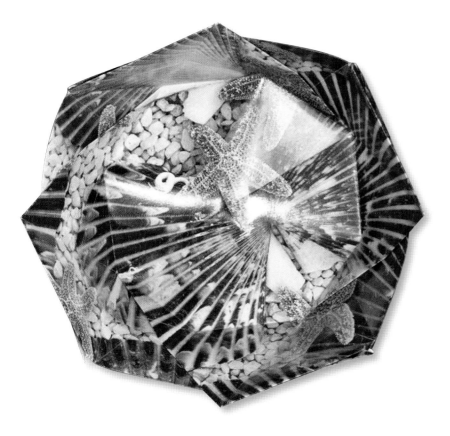

15. Repeat on the other three corners to complete Ali's Folded Dish.

Traditional Design

Masu Boxes

A masu box is a small, square, wooden box, originally used for measuring
grain. It served as inspiration for a ceremonial cup for sipping sake (rice
wine), but now the term is also commonly used to describe any similarly
shaped container. The origami masu is perhaps one of the few, totally-
useful things everybody should learn to fold, since it can be made larger or
smaller to form lids or liners (depending upon the use), all from squared-off,
recovered papers, plastics, and other flat materials.

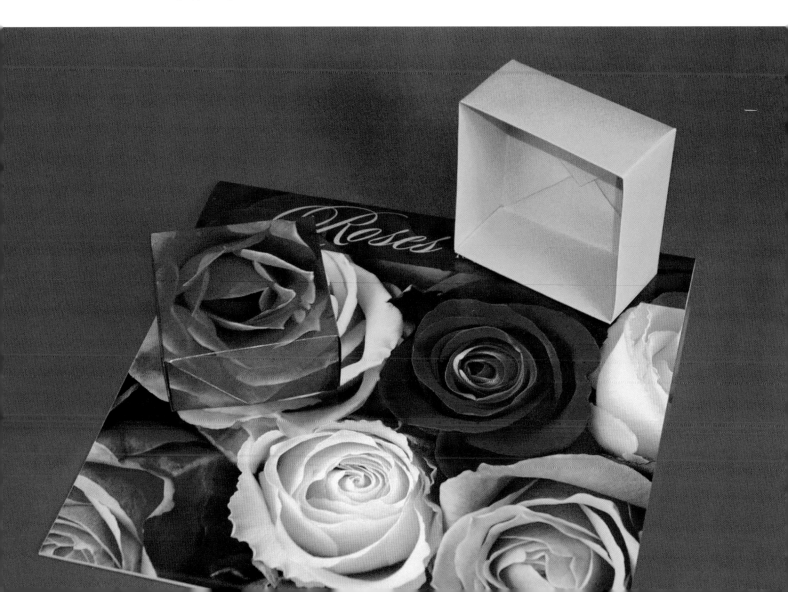

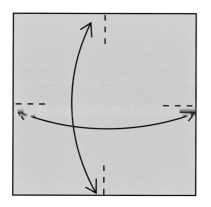

1. Begin with the display side of the paper facing up—colored side up if using origami paper. Fold each of the four edges in half, forming inch-long (2.5 cm) valley creases. These creases would mar the surface of the box, so they are kept short, but they are essential creases in steps four and five. Turn the paper over.

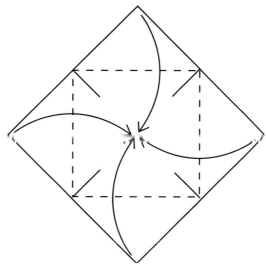

2. Fold each of the four corners to meet at the center. The short crease will act as a guide.

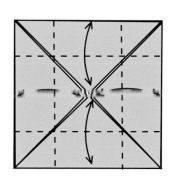

3. One at a time, fold each edge to the center of the paper, then unfold.

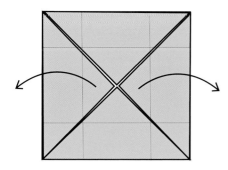

4. Open out the left and right triangle flaps.

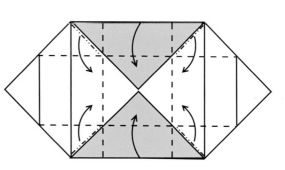

5. Begin to square up the box by mountain and valley-folding along the indicated lines. Look ahead at the next drawing to see it in progress.

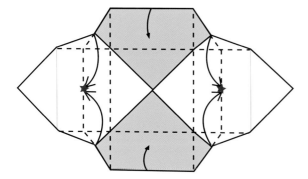

6. Fold the walls of the box so that they will be perpendicular to the floor of the box. Move the foldable corners to meet at the red stars.

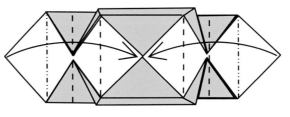

7. Fold the left and right flaps into the box to meet at the middle.

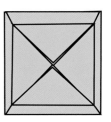

8. The completed Masu Box. Try making a Star Box Lid (Page 36) to fit!

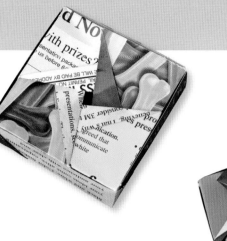

Designed by Richard L. Alexander

Star Box Lids

Richard Alexander designed this attractive box lid as a variation on the traditional weaver's shuttle box. Select four sheets of square paper for one lid. Squares cut to 3½ inches (9 cm) make a lid that is 2½ inches (3.5 cm) square. If you are making this lid to fit a Masu (see Masu on page 34) first quarter a same-sized square used for your Masu. (A Masu folded from an 8-inch (20 cm) square would need a box lid folded from four, four-inch (10 cm) squares.) Modify Step 8 to create different patterns or openings on top.

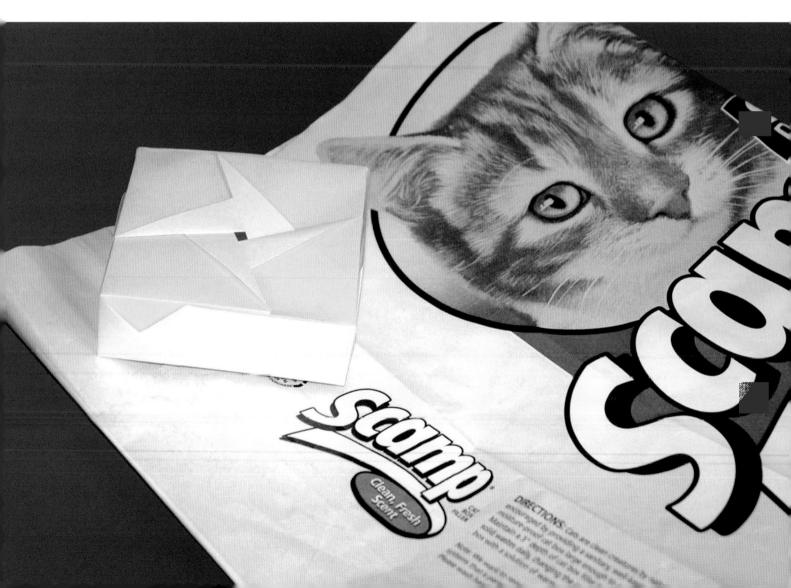

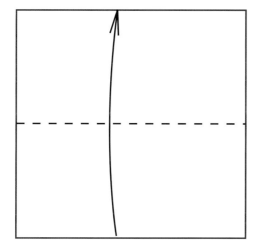

1. Fold in half, bottom edge to top edge.

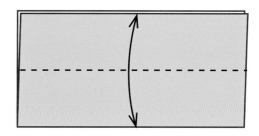

2. Fold the top edge—of the first layer only—down to match the bottom edge. Unfold.

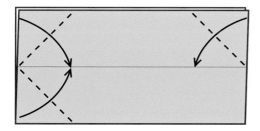

3. Fold the top left and right corners of the first layer down to the crease. Fold up the bottom left corner to the crease.

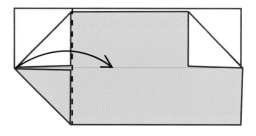

4. Fold the left side of the paper over, along the edges of the triangle flaps.

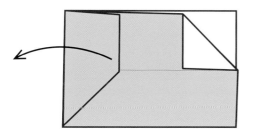

5. Return to the left.

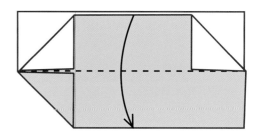

6. Fold the top flap down.

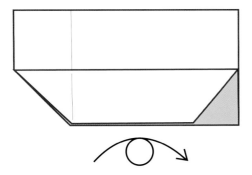

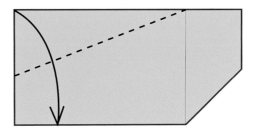

7. Turn the paper over, left to right.

8. Form a triangular flap from the top left corner by folding to square corner down to touch the bottom edge. Notice that the fold must also hit the top of the crease on the right.

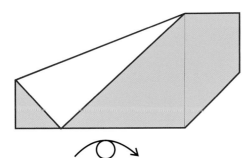

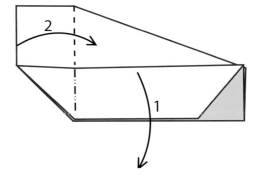

9. Turn the paper over, left to right.

10. Make the unit 3-D and box-like: 1. Lift the short layer set up, like a wall. 2. Move the left side up and to the right. Square off the corner formed there.

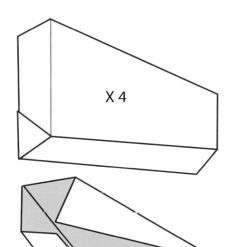

11. Here you see an inside and an outside view of the unit. You will need four to make one box lid.

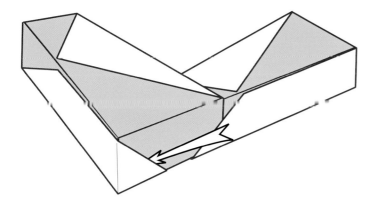

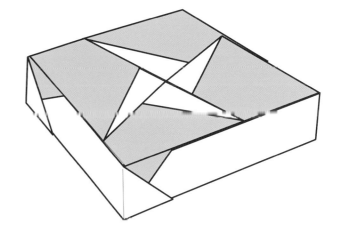

12. The lid units fit together by sliding the short end of one unit under the wide end of another. Notice that the short end also must slide behind the triangle layers at the corner of the other piece, inside and out. Add the other units in the same manner. Look at the arrangement of layers of the top display in the next drawing.

13. The completed Box Lid.

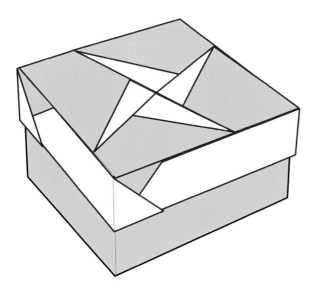

14. The Star Box Lid on a Masu!

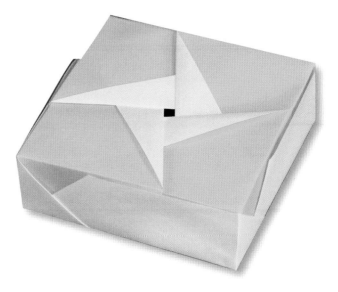

Designed by Michael G. LaFosse

Candy Wrapper Butterflies

Colorful candy and gum wrappers metamorphose into lovely butterflies. This project uses commonly found rectangles, which quickly and easily develop into butterflies with a wide variety of proportions, angles, and designs.

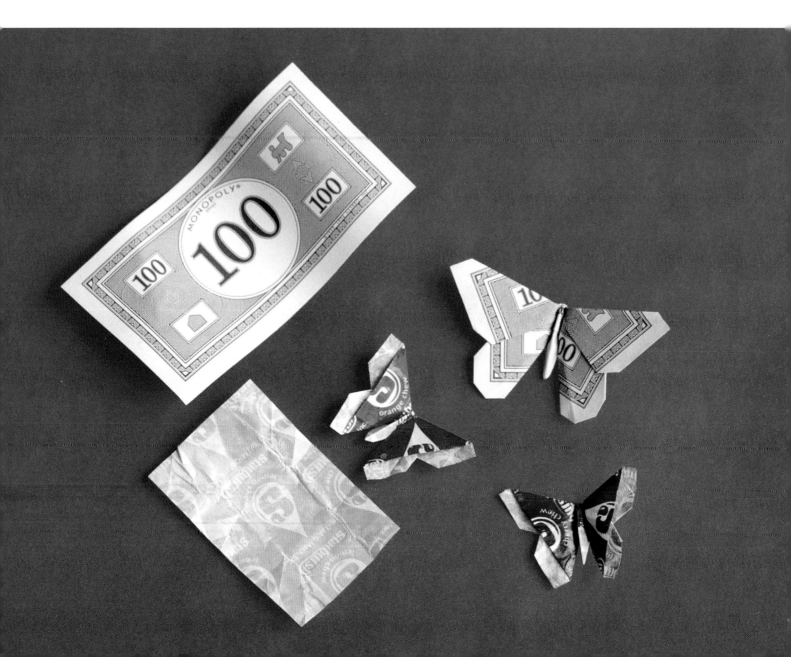

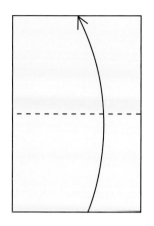

1. Begin with the display side of the paper facing up. Fold in half, short edge to short edge.

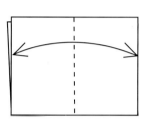

2. Fold in half by bringing the two double edges together. Unfold.

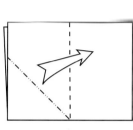

3. Squash-fold.

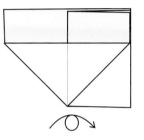

4. Turn the model over.

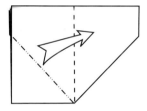

5. Squash-fold.

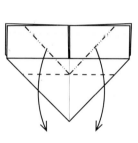

6. Fold the bottom square corner up to the top of the split. Unfold.

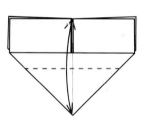

7. Use the crease from the previous step as a hinge to squash-fold the left and right upper layers for the wings.

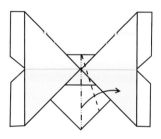

8. Mountain-fold the center of the paper to form a flap for the body. Rotate the flap over onto the right-side wing. Look ahead at the next diagram for the angle and the shape.

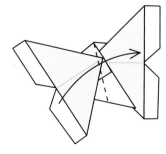

9. Fold the left-side wing over to cover the body and the right-side wing.

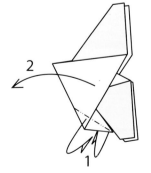

10. (1) Fold in the indicated edges of the underside of the body, forming a tapered shape. (2) Open the wings.

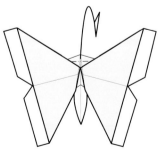

11. Flatten the top corner and fold it flat to the back, forming the head.

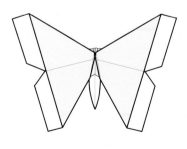

12. The finished Candy Wrapper Butterfly!

Designed by Michael G. LaFosse

Interlocking Flower Petals

Transform your colorful and shiny candy wrappers, pretty junk mail, photo magazine pages and other colorful scraps into a bouquet or garden of lovely flowers! You can use as few as four or as many as eight squares for each blossom (each one becomes a petal). Vary the sizes and petal shapes to make many different kinds of flowers. This demonstration requires six squares. Each is folded the same way. The design features a kite-shaped foot, and each half slides into a pocket, allowing the petals to become locked together without any glue. It is best to start with 3-inch (7.5 cm) squares, then progress to using smaller squares once you have mastered the project.

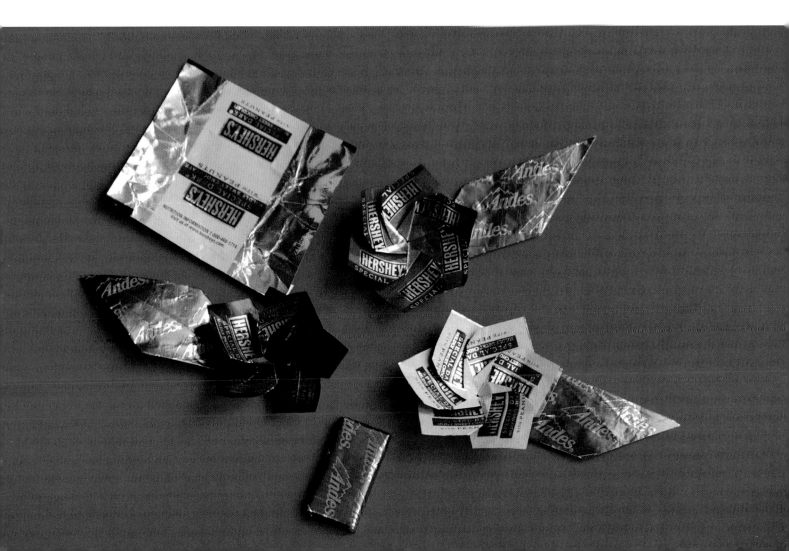

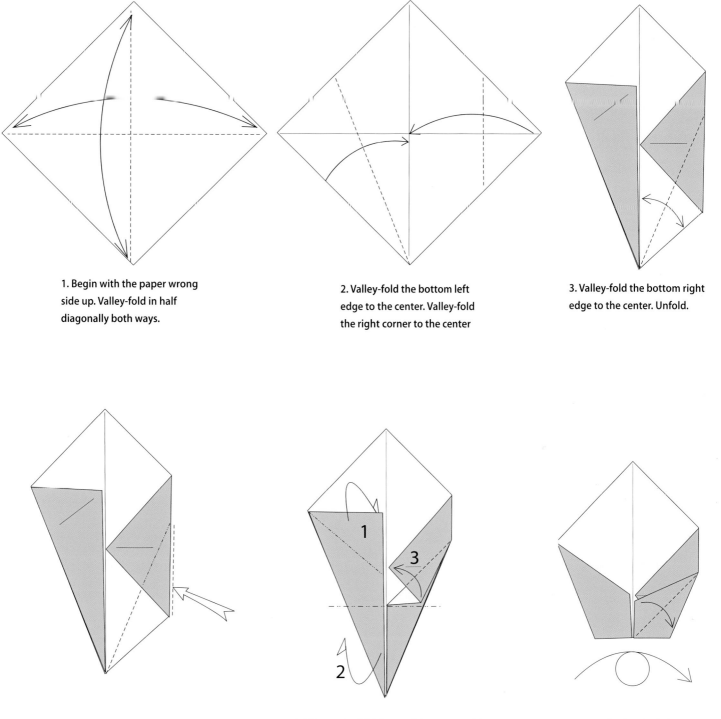

1. Begin with the paper wrong side up. Valley-fold in half diagonally both ways.

2. Valley-fold the bottom left edge to the center. Valley-fold the right corner to the center

3. Valley-fold the bottom right edge to the center. Unfold.

4. Inside-reverse fold.

5. (1) Mountain-fold the top left corner inside. (2) Mountain-fold the bottom corner up. Notice that the fold should happen at the level of the bottom edge of the inside-reverse fold on the right. (3) Valley-fold the lower flap of the inside-reverse fold up.

6. Bring the flap back down. Turn over.

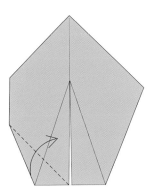

7. Valley-fold the bottom left flap up.

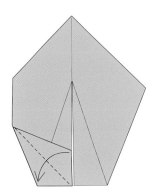

8. Fold the flap back down.

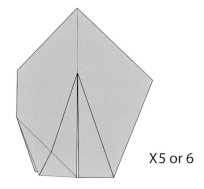

X5 or 6

9. The finished petal. You will need five to six petals to make one flower.

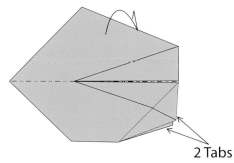

2 Tabs

10. Mountain-fold the petal in half. Notice the two tabs at the bottom right.

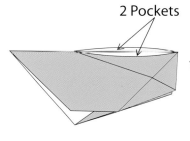

2 Pockets

11. Notice the two pockets at the top edge.

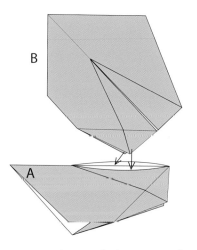

B

A

12. Insert the two tabs from one petal into the two pockets of another.

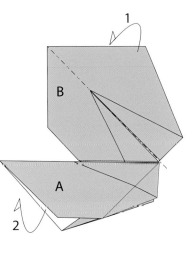

1

B

A

2

13. (1) Mountain-fold the new petal in half. (2) Move the back layer of the first petal up to make the petal full and flat. This locks the two petals together.

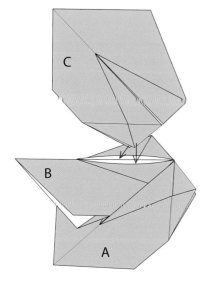

14. Add a new petal in the same manner.

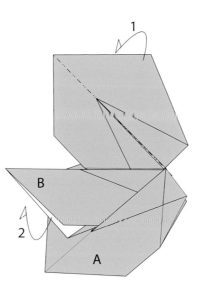

15. Be sure to first mountain-fold the newest petal in half and then open the previous petal, as before.

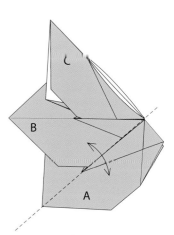

16. One more detail. Place a strong valley crease in the first petal. This will ensure the lock and begin to cup the blossom. Do this to each successive petal as you add new ones.

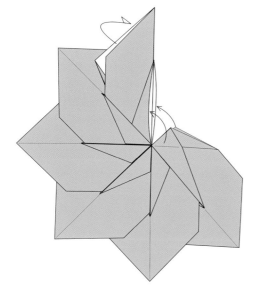

17. Once all of the petals have been locked together you can close the blossom by tucking the tabs of the first petal into the pockets of the last.

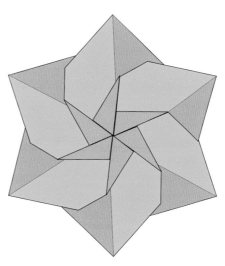

18. The Flower.

Designed by Michael G. LaFosse

Sailboat Envelopes

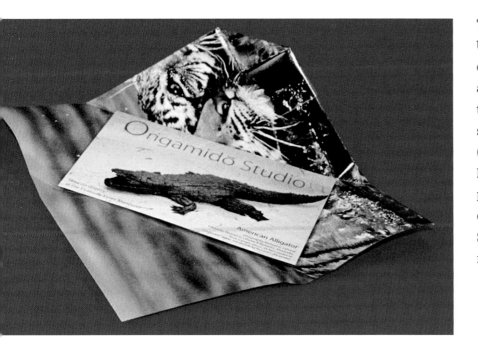

Traveling or launching an event? Use this clever and attractive envelope to send news from a vacation, or an invitation to a gathering. Use a square sheet that is at least 8 inches (20 cm) square, larger is even better. We use travel brochures, placemats, announcement flyers, or specialty wrapping papers. Squares cut from outdated nautical charts are perfect!

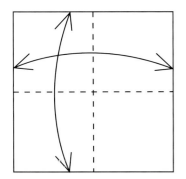

1. Begin with the display side of the paper facing down. White side up if using origami paper. Fold in half edge to edge both ways. Unfold.

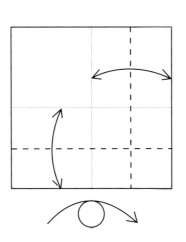

2. Fold the bottom edge to the horizontal crease. Unfold. Fold the right edge to the vertical crease. Unfold. Turn the paper over.

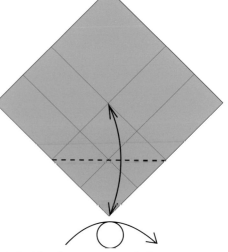

3. Position the paper to match the crease pattern that is displayed in the drawing. Fold up the bottom corner to the crossing crease at the center of the paper. Unfold and then turn over.

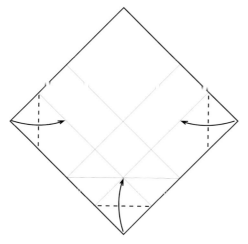

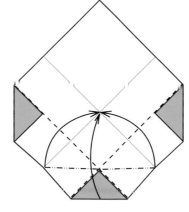

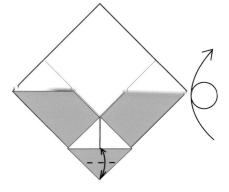

4. Position the paper to match the crease pattern in the drawing. Fold the bottom corner up to the lower set of crossing creases. Fold the left and right corners in, matching the top edges of these corners, each to the nearest crease.

5. Fold the bottom left and right edges inward, simultaneously. Notice that the bottom area will mountain-fold in two places to collapse the form. Look ahead at the next drawing for the shape.

6. If you folded step five correctly you will begin to see the sailboat forming. Fold the bottom corner of the sailboat up to touch the middle of the edge of the hull. Unfold. Turn the paper over, top to bottom.

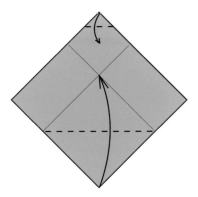

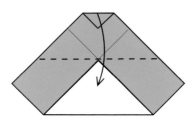

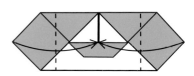

7. Using the crease formed in step six, fold the top corner down. Fold up the bottom corner to the center of the paper.

8. Fold the top half of the paper down at the level of the top corner of the large triangle flap.

9. You will see the sailboat again. Be sure that it is centered vertically. Fold the left and right corners in to meet at the center.

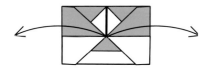

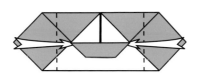

10. Unfold the left and right flaps.

11. Tuck the flaps behind the sailboat to seal the envelope.

12. The finished Sailboat Envelope.

Designed by Michael G. LaFosse

Flapping Bird Envelopes

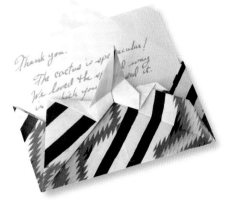

Whenever you receive a nicely wrapped gift, don't throw away the gift wrap! Say "Thank You!" by folding a sample square into this lovely and fun envelope. A 10-inch square (25 cm) works well. Birds folded from stronger papers flap better and last longer. The design allows for plenty of artistic and creative modification.

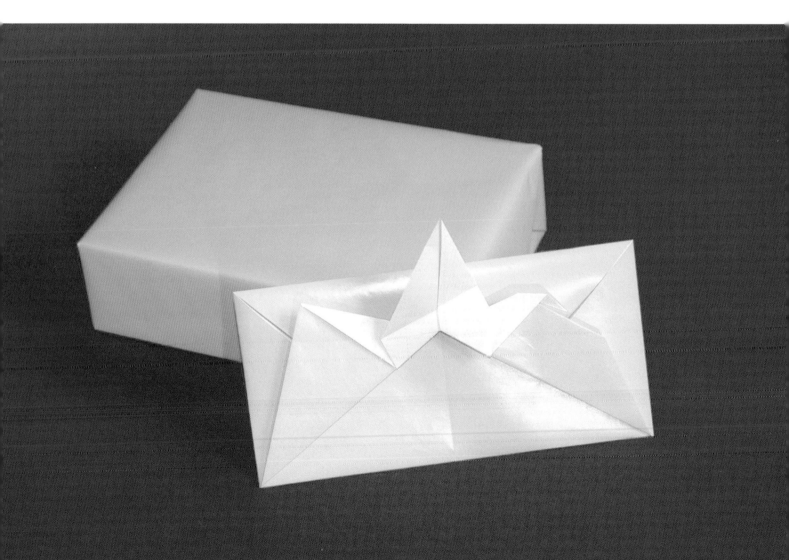

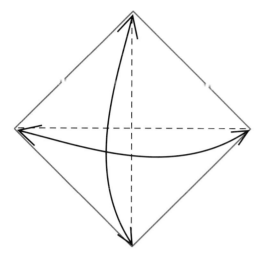

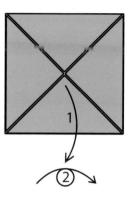

1. Begin with the display side of the paper facing down. White side up if using origami paper. Fold in half corner to corner both ways. Unfold.

2. Fold all four corners to meet at the center where the creases cross.

3. (1) Unfold only the bottom flap. (2) Turn the paper over, left to right.

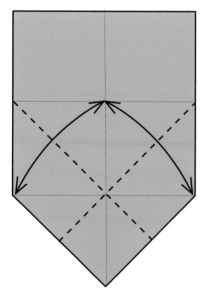

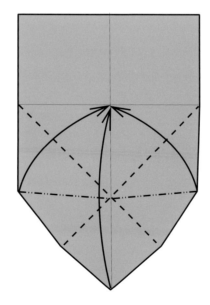

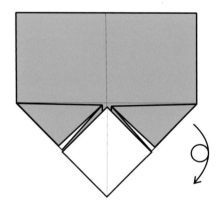

6. Turn the paper over, top to bottom.

4. One at a time, fold and unfold the bottom edges. Use the left and right obtuse corners to help: they should each touch the center crossing creases.

5. You now have a mountain and valley crease pattern that will let you move the bottom three corners to meet at the crossing creases in the middle of the paper. Look ahead at the next drawing to see the shape.

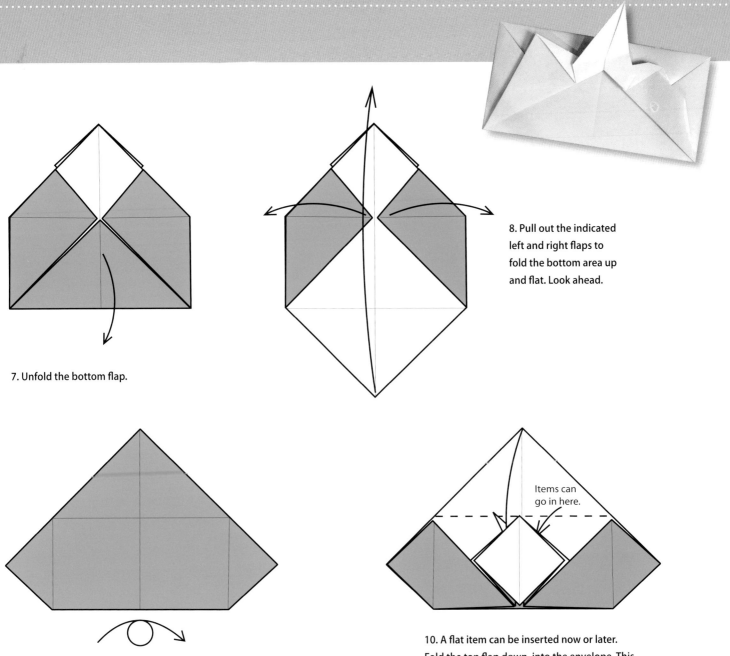

7. Unfold the bottom flap.

8. Pull out the indicated left and right flaps to fold the bottom area up and flat. Look ahead.

9. Your paper should look like this. Turn over, left to right.

Items can go in here.

10. A flat item can be inserted now or later. Fold the top flap down, into the envelope. This flap would also cover the inserted item.

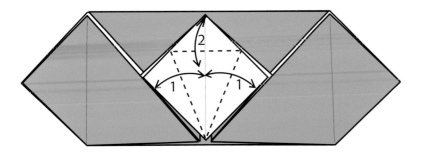

11. Pre-crease for a petal fold: 1. Fold the bottom left and right edges of the center shape to meet at the middle. Unfold. 2. Fold down the top corner at the level of the top of the creases just formed. Unfold.

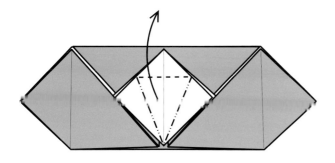

12. Petal-fold: lift the top layer up and fold in the sides as you flatten the shape into a tall diamond.

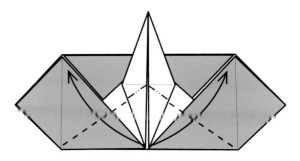

13. Inside-reverse fold the indicated points to form the neck and the tail of the flapping bird. A large flap of paper is attached to each and will follow.

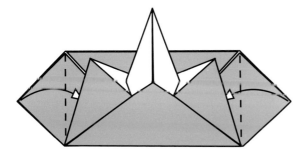

14. Fold the left and right corners inward and behind the flaps, locking the envelope.

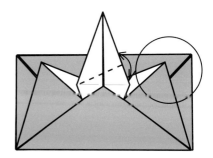

15. Install the fold in the wing, toward the head. (The head will be formed at the point in the circle on the right.) You could use the left side point for the head, and fold the wing toward the left.

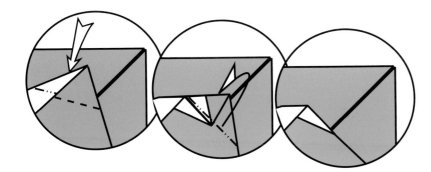

16. Inside-reverse fold the tip of the right point down for the head. Fold the excess flap behind the head.

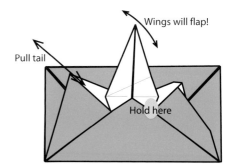

17. The finished Flapping Bird Envelope. Hold the envelope at the base of the bird's neck, then pull the tail in and out to make the wing flap. Now that's airmail!

Designed by Michael G. LaFosse

Shuttle Darts

Paper airplane designs are a specialty of mine, and being an origami creator I prefer not to use any adhesives, fastening appliances, nor cuts. I designed this little paper dart with those constraints in mind. It is best folded from 6- to 8-inch (15 to 20 cm) squares, and many kinds of paper can be used. Have fun experimenting with all kinds of scrap materials. Try your hand at redesigning the shape of the wings and the fins. Try adapting this design to rectangles of other proportions, too. Using throwaway papers and other scrap materials at hand provides engineering challenges that can be quite fun. Enjoy!

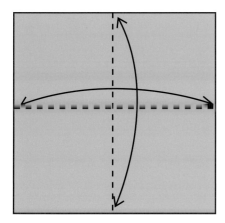

1. Begin with the display side of the paper up, colored side up if using origami paper. Fold in half, edge to edge, both ways. Unfold.

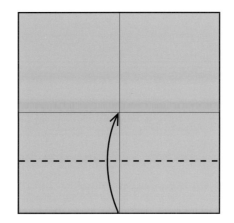

2. Fold the bottom edge up to the center crease.

3. Turn over, left to right.

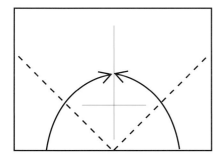

4. Making sure the folded edge is at the bottom, fold the left and right halves of the bottom edge to meet in the middle.

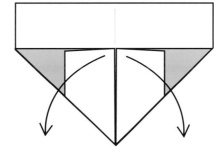

5. Unfold the last step.

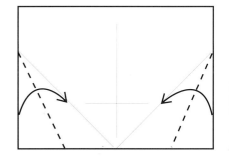

6. Fold the left and the right edges to the new creases.

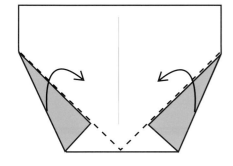

7. Fold over along the creases.

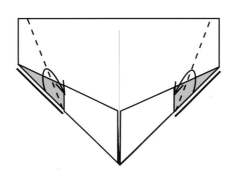

8. Fold the indicated edges to the vertical dividing lines of color and white, forming the fins.

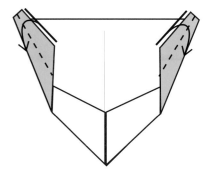

9. Fold the indicated long edges of the fins to the outer edges of the wings.

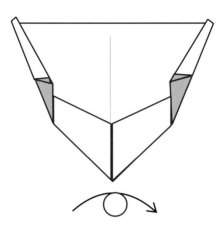

10. Turn the model over, left to right.

11. Notice the triangle layer of paper in the nose. We shall prepare it for my origami nose lock!

12. Fold the right corner of the triangle area in half. Unfold. Fold the left corner of the triangle area in half. Unfold. You will have crossing valley creases in the nose.

13. Use the "V" shaped valley crease at the center of the triangle to move the long edge of the triangle into the nose as you fold the plane in half. The creases will show you where to make this fold.

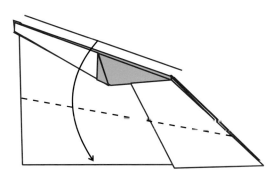

14. Fold the wing down on one side of the plane by matching the indicated wing edge to the bottom edge of the plane.

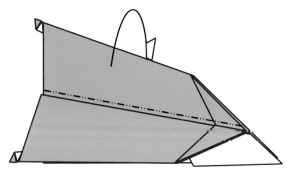

15. Repeat on the other side with the other wing.

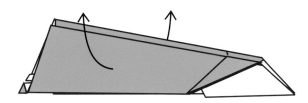

16. Lift the wings up and set them straight out to the sides, or slightly above the body of the plane.

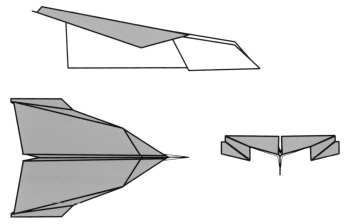

17. Adjust the fins to form a stair step shape. You now have a Shuttle Dart. The nose is locked: no paper clips, staples, or tape!

Designed by Michael G. LaFosse

Art-Deco Wings

My Art-Deco Wing allows young minds to ponder form and function, while teaching valuable lessons in materials choice proven through performance testing. There are many other interesting aspects you can learn or discover from folding and launching this stackable, flying wing from a variety of found papers. It has an amazingly high glide ratio; it is capable of elaborate stunts; it can be stored flat, but it is always ready to go! Include this wing in one of the envelope projects and mail it to a friend.

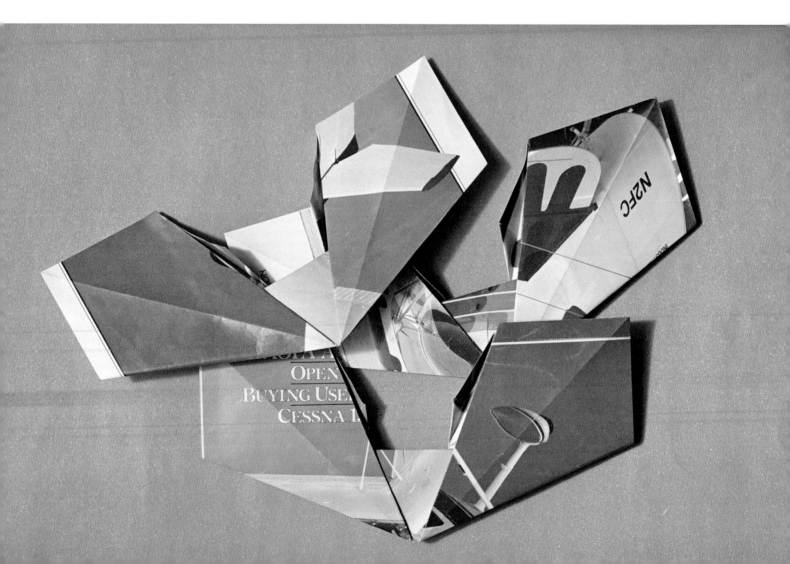

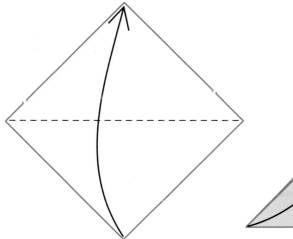

1. Begin with the display side of the paper down. Fold in half diagonally.

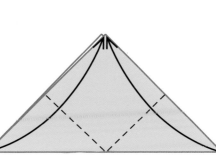

2. Fold the bottom corners to match the top corner.

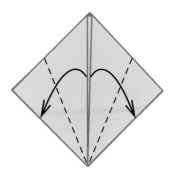

3. Fold the indicated edges to match the outer edges of the paper.

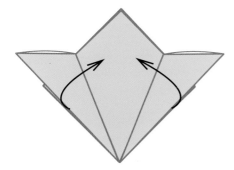

4. Return the edges to the center.

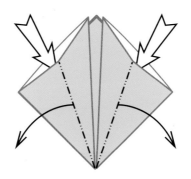

5. Open the layers of each of the two triangle flaps, like a cone. Flatten into kite shapes. Look ahead at figure six.

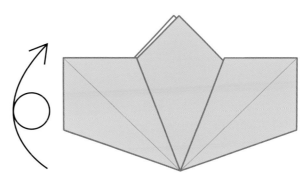

6. Turn the paper over, top to bottom.

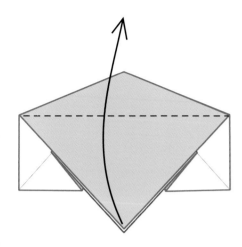

7. Fold the large flap up.

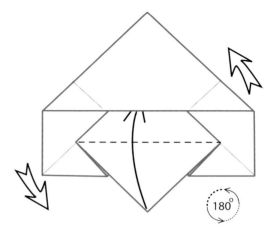

8. Fold the indicated flap up and tuck it inside the paper. Rotate the model 180 degrees.

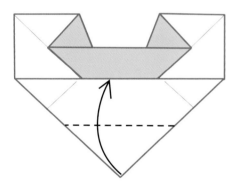

11. Fold the indicated flaps up to the folded edge.

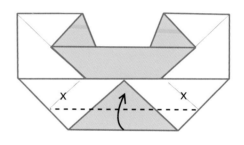

12. Flip the indicated flap up.

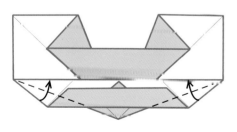

9. Fold the corner of the bottom flap up to touch the middle of the folded edge, above.

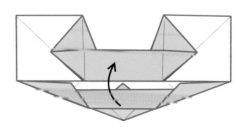

10. Fold the bottom edge up. Keep this flap within the creases.

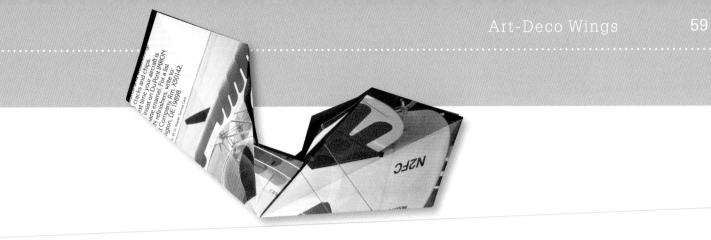

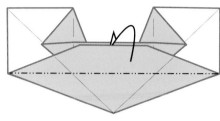

13. Turn the flap inside the model.

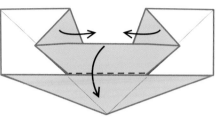

14. Fold the middle edge down, and tightly against the top edge of the triangular nose area. Push the indicated corners inward to open the paper for squash-folding.

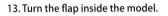

15. Continue to move the middle edge downwards while pushing the side corners inward and down to flatten. Look ahead at the next diagram.

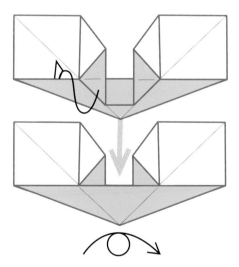

16. Tuck the flattened flap inside the model. Turn over.

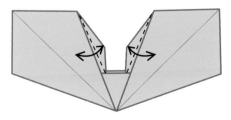

17. Fold the indicated flaps tightly over the back edges of the wings, then stand them vertically away from the wings. These are the vertical stabilizers.

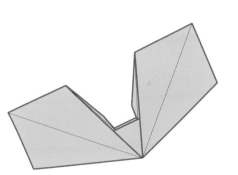

18. The Art-Deco Wing. Launch it as high as you can, anyway you can, to enjoy a loop and a long slow glide. Experiment with different papers—different sizes, too!

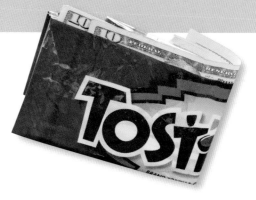

Designed by Michael G. LaFosse

Snack Bag Wallets

This simple yet versatile design can be applied to all kinds of strong, flat bags and foldable tubes. Try used Tyvek™ envelopes! The several "secret" compartments are a big hit with the coupon-clipping-collecting-organizing crowd. For the über-organized, make bigger wallets to hold your bigger coupons, and to hold your smaller wallets full of smaller coupons. Color-coordinate your wallets to the coupons inside. If you use paper bags to fold the wallets, decorate them with permanent color marking pens, or paint that won't come off in your pocket!

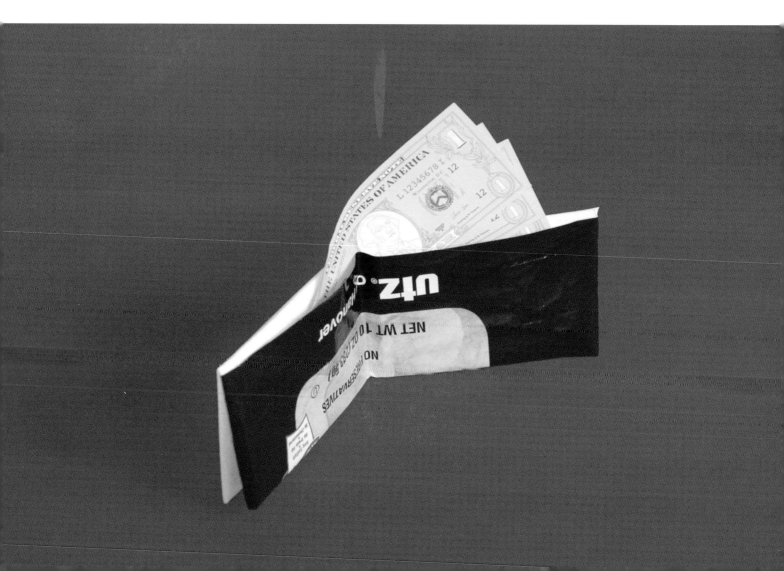

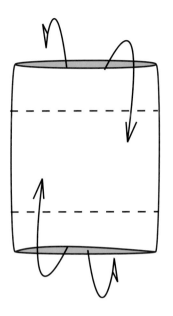

1. Cut the top and bottom off a large snack bag or envelope, forming a flat tube. (Thoroughly clean and dry used snack bags.) Turn the tube inside out.

2. Turn each open end inside out and make their edges meet at the outside middle of the tube.

3. These open layers are the pockets for the wallet. Chose which area of display you wish to show on the outside, then fold in half lengthwise.

4. Again, choose the best display, then fold in half.

5. The finished Snack Bag Wallet. Use it to hold store coupons and your shopping lists.

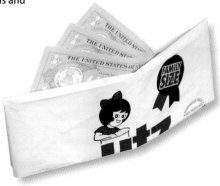

Designed by Michael G. LaFosse

Bag Ballot Boxes

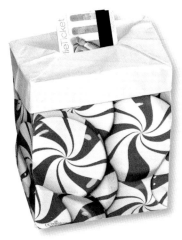

Use any box-folded paper sack to create this decorative, slotted closed-topped container! The top will be a well-locked and attractive rectangle. Once completed it can serve as a ballot box or a receptacle for raffle tickets; just feed them into the slot!

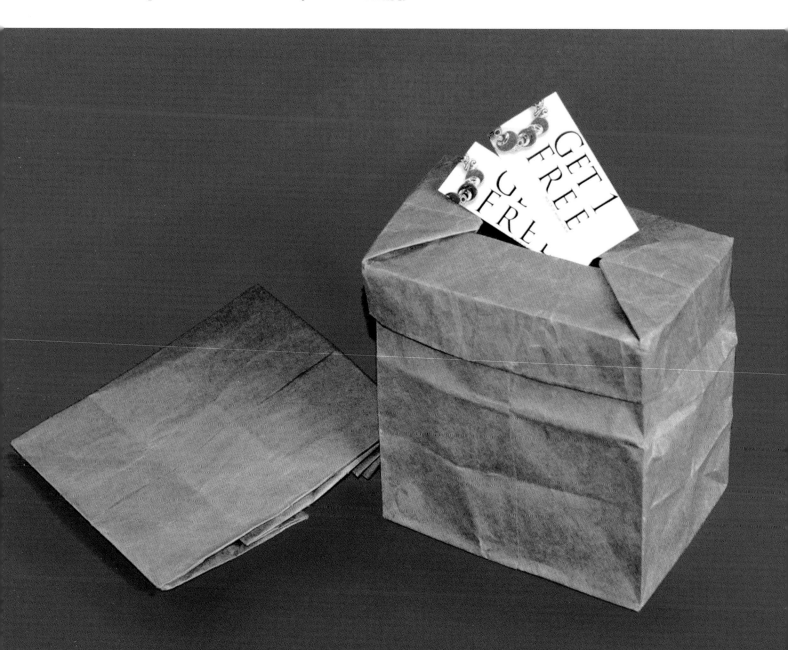

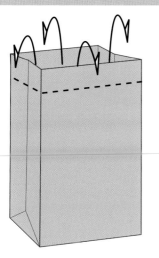

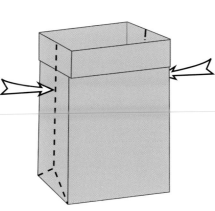

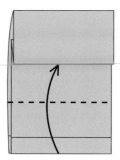

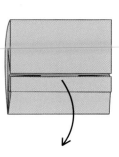

1. Open the bag and fold over an inch (2.5 cm) of the open rim.

2. Collapse and flatten the bag.

Flip top to bottom.

3. With the rectangular bottom of the bag visible, fold the open end to the edge of the bag bottom, creating a segment for the closure folds to form within.

4. Open out the segment, keeping the rest of the bag flat.

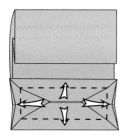

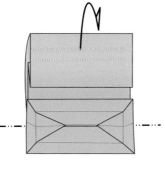

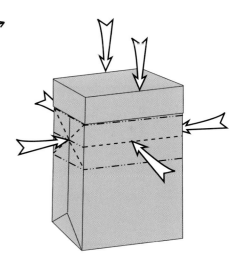

5. Squash-fold the layers of the bottom area of the open segment while forming four walls around it. The area will look like a shallow, rectangular tray.

6. Fold the rest of the bag down and to the back, making the creases flexible between the tray segment and the body of the bag.

7. Unfold the tray segment and open the bag.

8. Collapse the bag below the creases formed for the tray and re-form the tray area on top. You may place items in the bottom half of the bag before your do this or you may complete the top closure to make a hollow box.

9. Turn the rim of the top tray section inside out and press down over the body of the bag.

10. The completed Ballot Box.

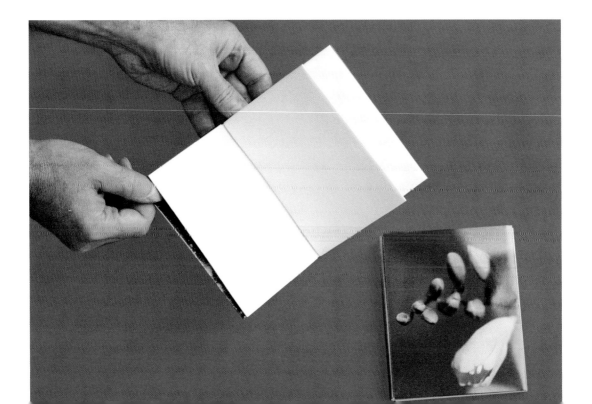

Designed by Rona Gurkewitz, USA

Custom-Bound Books

This book is easily made from just about any kind of rectangular sheets, even squares! The ingenious design is infinitely and easily expandable, and needs no other types of fasteners! Posters, flyers, magazine and calendar pages are excellent for decorative covers. The backs of printer scrap paper (printed on one side, yet blank on the other) can form the blank pages (to write on), and other discarded pages (printed on both sides) make the perfect connector units, since nothing shows. You can even lay out your pages in your word processer, and set your printer to print only the portions of the page that will be exposed in the finished book, in order to pre-print text and images of the stories you wish to share with your highly personalized, custom-bound book! You will need at least ten sheets of rectangular or square paper that measure the same size and dimension. Printer paper is ideal. Three sheets will be used for the pages of this book; four sheets to form connecting units; two sheets to form the covers and one sheet to form the spine.

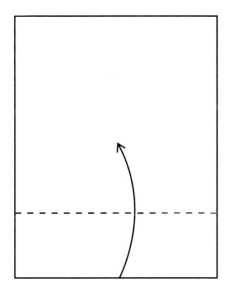

1. **Pages:** fold one of the short edges to lay midway up the sheet. Close is good enough.

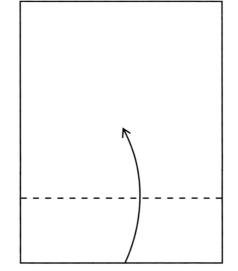

2. Fold the opposite edge to meet it there. You will have a neat rectangle with a horizontal split.

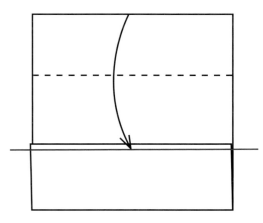

3. Fold in half, short edge to short edge, with the split inside.

X 3

4. The finished page unit. You will need three of these.

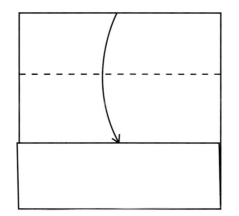

5. **Connector Unit:** fold one of the short edges to lay midway up the sheet.

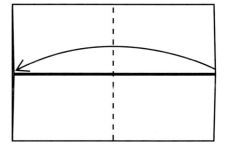

6. Fold the opposite edge to overlap, by about an eighth of an inch (5 mm) or so, making the connector unit narrower that the page units. Connectors must fit into pages. You can check the fit by inserting the connector into the open side of a page unit. Make adjustments and use your adjusted unit as a guide for the others.

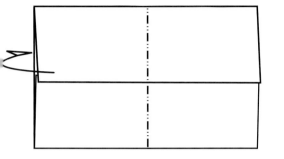

7. Fold in half, short edge to short edge, with the split on the outside.

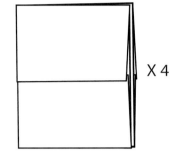

8. You will need four connectors.

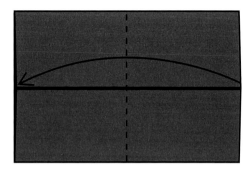

9. **Covers:** fold the short edges of a sheet to meet at the middle of the paper, the same as for folding the pages. Fold in half, short edge to short edge, split inside.

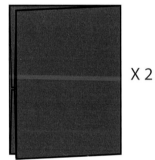

10. You will need two covers.

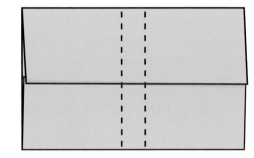

11. **Spine:** fold the two short edges of sheet to overlap slightly at the middle of the paper, the same as for folding the connector units. Valley-fold two parallel creases, about a half-inch (1.5 cm) apart, split inside. You should make the space between the creases larger if your book is thicker.

12. Square up the spine so that it looks like this. You will need only one spine.

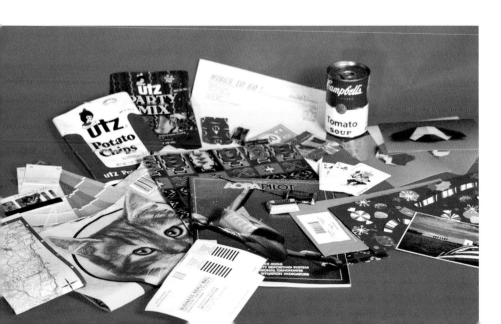

13. Assembly: use a connector unit (yellow) to connect one cover (red) and one page (white) together. The connector's flaps slide into the page and cover units.

14. Notice that both the cover and the page each have one free flap.

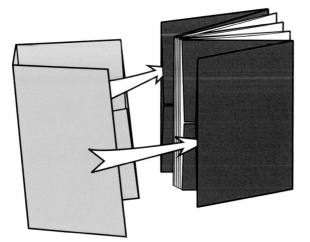

15. Use the connectors to attach the remaining pages and the other cover together in a fan-folded form. Slip the flaps of the spine into the free ends of the covers.

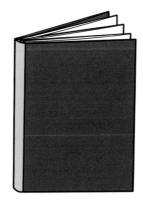

16. The completed Book!

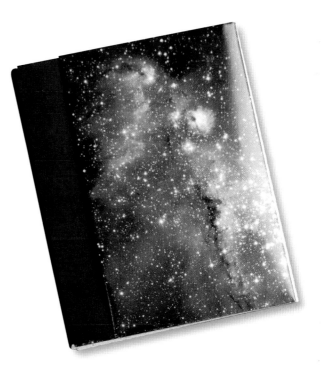

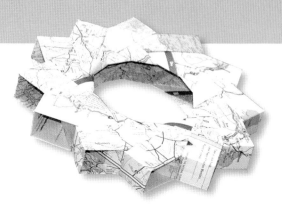

Designed by Michael G. LaFosse

Calendar Wreaths

The modular, flat, origami wreaths and rings designed by Mette Pederson (USA) have inspired many folders all around the world. Paolo Bascetta's (Italy) inspiration was to make a flat "Mette ring" into a three-dimensional "Mette-Bascetta ring," which inspired me to create an origami design system for quickly making 3-D "Mette-Bascetta-Lafosse rings" from a handy jig, or tool. This project uses twelve square sheets (plus another used for the measuring tool). You can use just about any kind of paper for this project. However, recycling a square-shaped paper calendar is an ideal choice: one month for each element! A calendar, which you have received from a friend, can be transformed and sent back to them as a New Year's greeting!

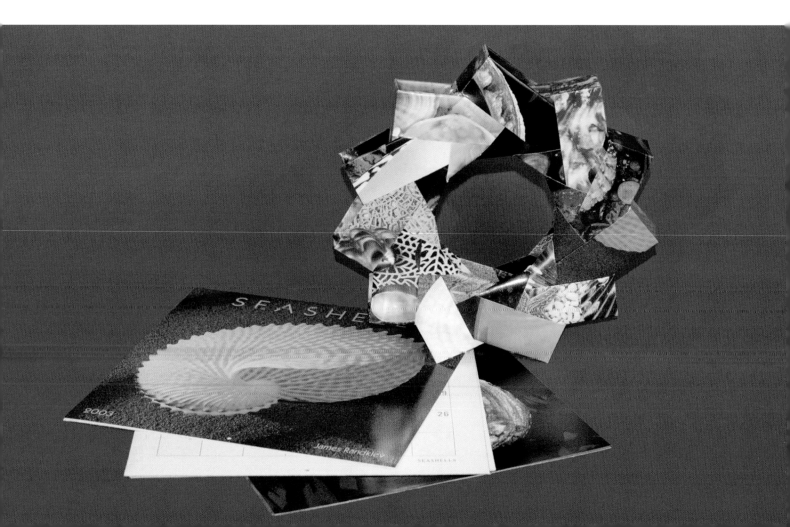

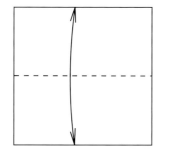

1. Begin by folding the measuring tool, also called a "jig": Use a square of the same size you will use to fold the 12 units for this project. Fold in half, edge to edge. Unfold.

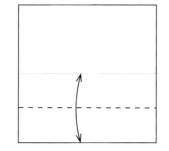

2. Fold the bottom edge to the center crease. Unfold.

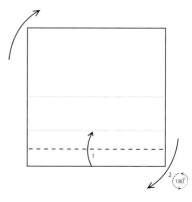

3. (1) Fold the bottom edge to the new crease. (2) Rotate the paper so that the folded edge is at the top.

4. The finished measuring tool.

5. Insert the top edge of your first square for the wreath, tightly under the folded edge of the tool.

6. Fold the bottom edge of the inserted paper up to meet the folded over edge of the tool.

7. Unfold.

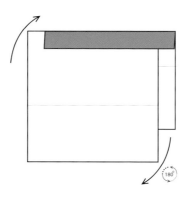

8. Remove the paper and rotate it to insert the opposite edge into the tool.

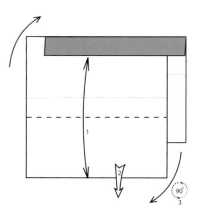

9. Fold the new bottom edge of the inserted paper, unfold and remove. You will have two parallel creases defining a channel in the middle area of the square. Rotate the paper so that these creases run vertically.

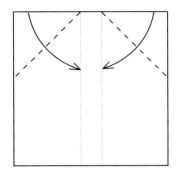

10. Fold the top corners of the square down, forming triangle flaps. Align the corners with each vertical crease, as shown.

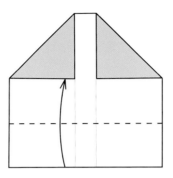

11. Fold the bottom cut edge up to the match the bottom edges of the triangle flaps.

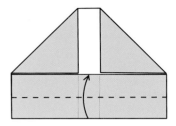

12. Fold the new, bottom fold edge up to the same place.

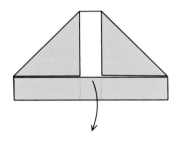

13. Unfold the bottom layers.

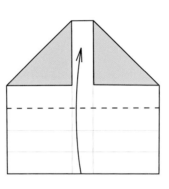

14. Fold the bottom edge up, bending at the topmost horizontal crease.

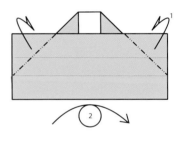

15. (1) Fold the indicated corners closely over the sloping edges, behind. (2) Turn the model over, left to right.

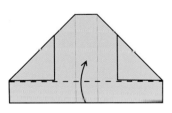

16. Fold along the bottom edges of the triangle flaps, moving the bottom edge up.

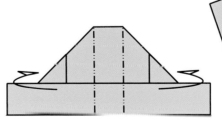

17. Mountain-fold along the two parallel vertical creases, forming right angles to the center of the paper to complete the wreath unit.

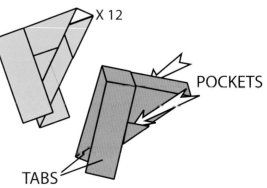

18. You will need a total of 12 units to build one wreath. Each unit has two pockets and two tabs.

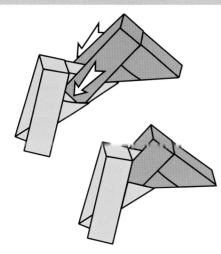

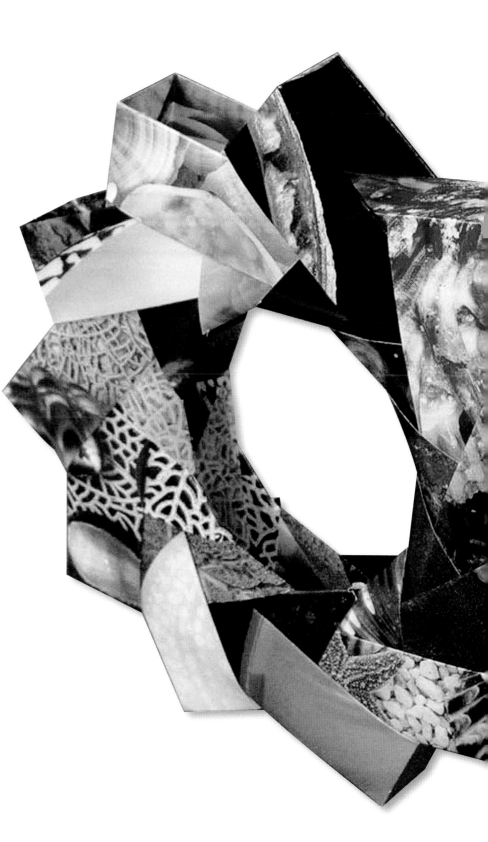

19. The units fit together by inserting the tabs into the pockets, one on each side. Keep the units square and box-like as you build.

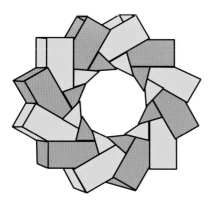

20. The Calendar Wreath. A great ornament for any anniversary!

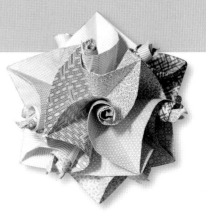

Designed by Herman Van Goubergen, Belgium

Curler Unit Balls

Herman has eloquently transformed a simple, traditional origami base structure into a unique module that is full of creative potential. His "Curler Unit" is the familiar "waterbomb" base, only with tightly-curled flaps. Assemble these Curler Units into a multitude of dazzling forms, and experiment by varying the number of pieces involved. Heavy papers often work the best when moistened slightly. Allow them to dry in the curled shape before assembly. Old greeting cards become a colorful source of materials! For this project you will need 12 same-sized squares (in the 3 to 6 inch (7.5 to 15 cm) range). You can cut origami paper into quarters to make smaller sheets, since that type of paper is a bit too flimsy for large models.

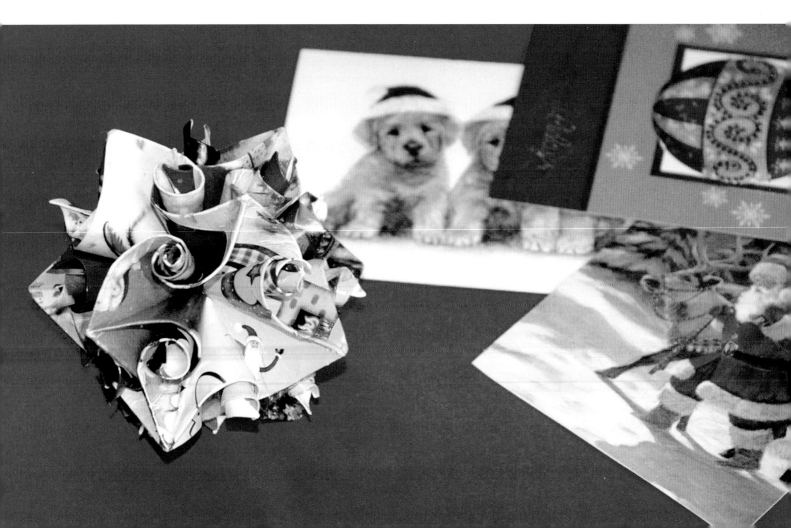

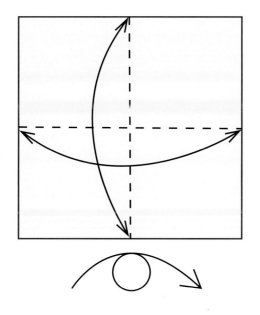

1. Begin with the display side facing up. Fold and unfold in half, edge to edge both ways. Turn the paper over.

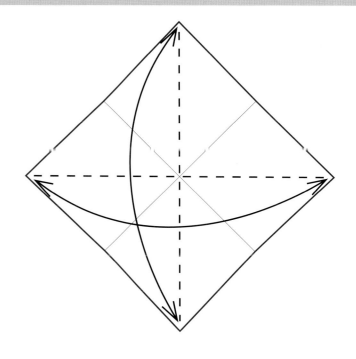

2. Fold and unfold in half, corner to corner both ways.

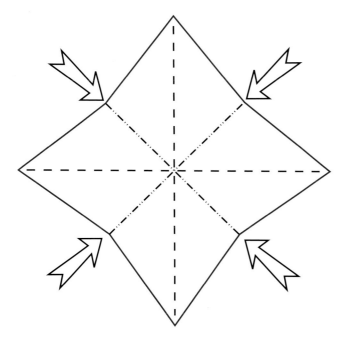

3. Push in the middle of each of the four edges of the square to form a four-point star. The creases will easily yield to this shape.

4. Your "star" will have four triangle-shaped flaps

5. Tightly curl a flap into a conical spiral.

6. Repeat with the other flaps. Be sure that all four curls spiral in the same direction.

7. The finished curler unit. Make twelve.

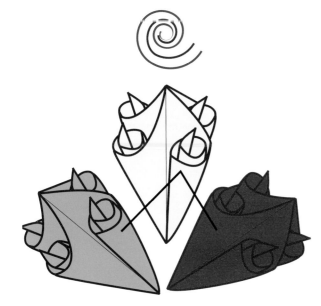

8. Intertwine one curl from each of three modules, linking them together at a common hub.

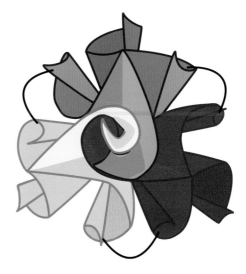

9. Intertwine two adjacent curls between each of the three units.

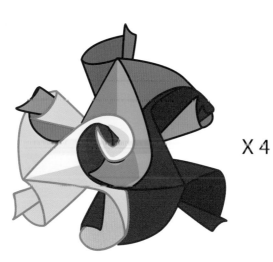

10. A completed sub-module. You will need four sub modules.

11. Connect the sub modules by intertwining doubled twists with doubled twists (forming quadruple twists) and making triple twists out of single twists. The developing quadruple twists are indicated by the number 4, and triples by the number 3.

4

3

4 4

3 3

4

3

12. The completed Curler Unit Ball.

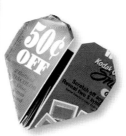

Based on a design by Florence Temko, USA

Paper Hearts

Florence was an origami pioneer and very dear friend of ours. Her clever designs delighted us as children, and continue to be the most loved origami designs for greeting cards, and all celebrations of friendship and hospitality. This charming heart can quickly be folded from most rectangular scraps of paper, making it easy to do and to remember. You will surely find many uses for it beyond Valentine's Day.

1. You can use a US one dollar bill, or a rectangle of similar proportions: approximate ratio of 1: 2.33. Here we have used a soup can label! Begin with the wrong side up. Fold in half, short edge to short edge. Unfold.

2. Fold each half of the bottom edge to meet at the crease.

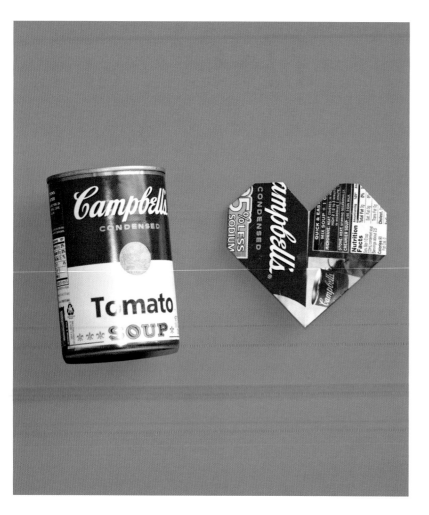

3. Your paper will look like this, and the display colors will show. Turn the paper over, left to right.

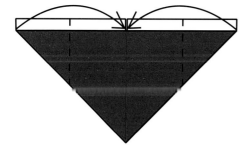

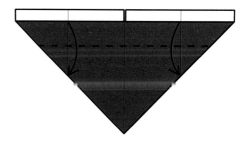

4. Fold the left and right edges to meet at the middle.

5. Return the edges to their original place.

6. Using the left and right vertical creases, formed in the last step, fold the top front edge down to align with the bottom of the vertical creases.

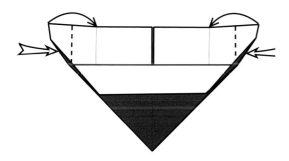

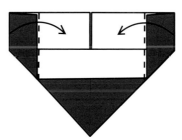

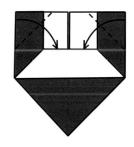

7. A large pocket will open at the left and the right of the model. Push the outside edges inward to the nearest vertical crease and flatten.

8. Your paper should look like this. Fold the indicated left and right sides in along the vertical creases.

9. Fold the top corners down to match the folded horizontal edge.

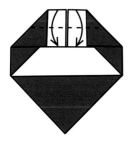

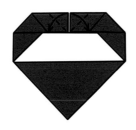

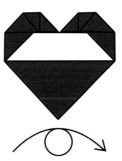

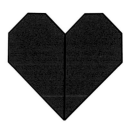

10. Fold the top edges down to the same edge.

11. Fold the top center corners down to the same edge.

12. Turn the model over, left to right.

13. The Heart.

Designed by Vincent Floderer, France

Crumpled Mushrooms

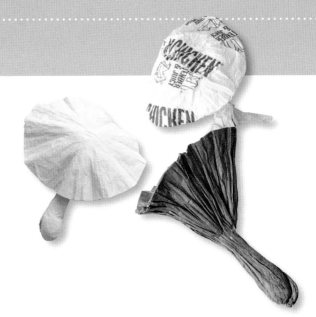

Vincent Floderer's creative work in crumpled paper folding is spectacular. This simple mushroom will let you try your hands at it. Although many assume these shapes to be born from anarchy, there is underlying origami structure without all of the painstaking crease placement. You will be "wet-folding," too, and it will be a little bit like working with clay. We recommend that you visit Vincent's web site "Crimp" at www.le-crimp.org to see more stunning examples of the marvelous paper transformations his group is creating.

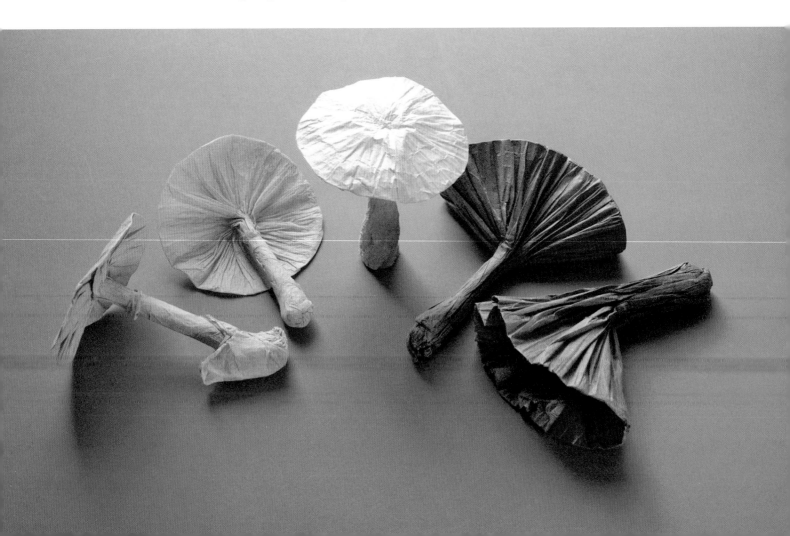

1. Use a large square of strong, thin wrapping paper. For your first attempt, a sheet measuring approximately 18 inches (45 cm) is ideal. You will also need a drinking glass half filled with water. The water is for wetting and shaping the stem.

Hold the paper horizontally on the palm of one hand and grasp the center with the thumb and index finger of your other hand. Pinch the center, and with your other hand, flute the paper into a narrow cone shape. Tightly compact this fluted cone into a slender stick shape.

2. Pull gently on opposite corners and carefully spread the paper fully open.

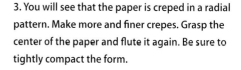

3. You will see that the paper is creped in a radial pattern. Make more and finer crepes. Grasp the center of the paper and flute it again. Be sure to tightly compact the form.

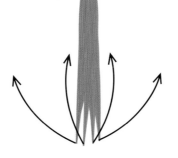

4. Once again, carefully spread open the paper. You can repeat the fluting and crushing several more times if you wish, but two to three times is usually sufficient.

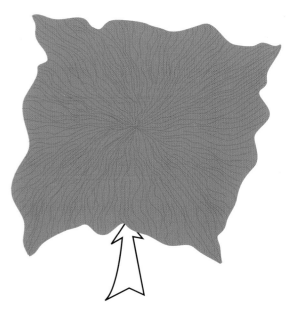

5. Place your fist under the center of the paper and form a dome in the middle.

7. Tightly collapse the volcano into a slender stick shape.

6. Push the center of the dome down and into the paper, forming a crater. You can pinch a circular outline, like the rim of a volcano, around the perimeter of the crater. The depth of the crater will be the approximate radius of the mushroom cap. The deeper the crater the wider the cap; and, consequently, the shorter the stem. So, it is wise to imagine the desired proportions of the mushroom while you make this fold.

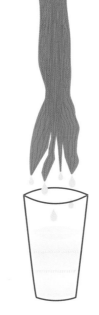

8. Find the original four corners of the sheet and refine them into slender, separate points.

9. Dip the bottom of the mushroom into a glass of water, wetting the bottom third of the paper.

10. Lift the paper out and let it drain for a moment, then gently squeeze more water out. Once again, find and separate the bottom four corners.

11. One at a time, gently spread out a corner and lift it up onto the stem. Do this with each of the four corners, spreading and overlapping as you go.

12. Tightly compress the wet part of the stem. Be sure to do this over a towel or the glass of water, as more water will come out.

13. Dip the bottom of the stem into the water once again. You will be able to fit more of the stem in since it has shortened. Be aware of where the paper for the cap is and try not to get that area wet. Right up close to it is ideal.

14. Lift the paper out of the water, let it drain and then squeeze out more water.

15. Refine the bottom shape. Try to shape the bottom of the stem into a bulbous form, tapering up towards the cap. Open and spread out the paper at the top to form the cap.

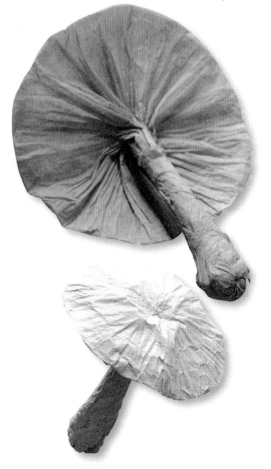

16. Floderer's Mushroom with very convincing gills! You can be very creative with this method. Vincent has made many kinds of mushrooms this way. Look at pictures to see other kinds, like chanterelles, shitake, and oyster mushrooms. Vincent often adds other distinguishing features, such as the ring (annulus) around the stem, just under the cap, and the cup (vulva) at the base of the stem.

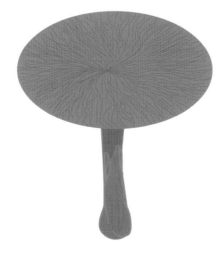

Traditional

Pinwheel Envelopes

This marvelous fold is sometimes called the "Thread Case" and it has been used in China and elsewhere to hold small objects such as threads and needles. Handy items tuck beneath the interlocking flaps on top, but the lower chamber is its secret compartment, reserved for precious or dangerous items such as needles. This becomes an extra surprise when you use it to present a gift. You can even include layers of messages and surprises! Use any paper, or even fabric. The tricky part of this model is in the equal division of the paper into thirds. If you trim your square to measure a length that is divisible by three, you will have no trouble making guide marks. You can also roll over each side to estimate a third, and then adjust the flaps to meet the folds, resolving the discrepancy before committing the folds with creases.

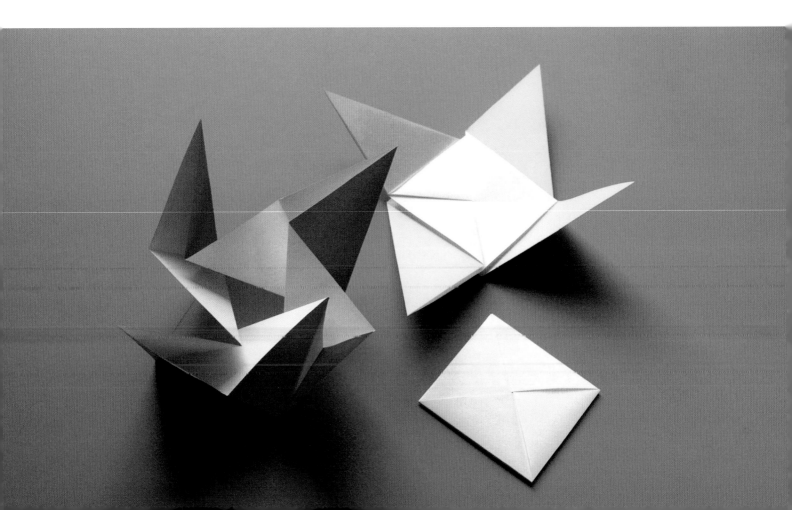

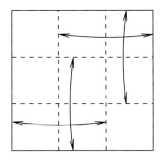

1. Begin with the inside surface facing up. Valley-fold into equal thirds, both horizontally and vertically, forming a nine-square grid.

2. Turn over.

3. Valley-fold a diagonal crease in the center square in the bottom row, by folding the bottom edge to the vertical crease on the left-side.

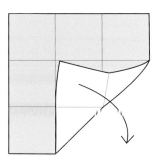

4. Unfold.

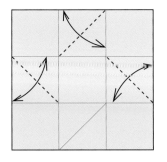

5. Repeat with each of the other three center squares around the outside. Be sure to pay close attention to the correct direction of each crease.

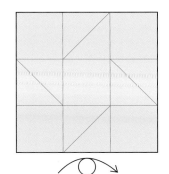

6. Turn over.

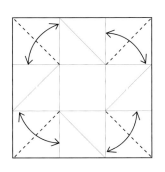

7. Valley-fold each of the corner squares diagonally in half.

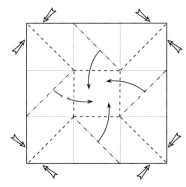

8. Notice the four highlighted mountain creases, indicated in red. Make these bend first, then the valley-folded corners and the center square to form a pinwheel-shaped dish. Look ahead to see the shape.

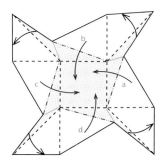

9. Close and flatten the envelope's secret compartment by weaving triangular panels a, b, c, and d, twisting the paper into the shape of a pinwheel.

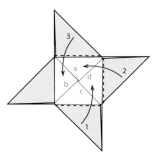

10. Weave the first three corners together, beginning at the bottom and proceeding counter clockwise.

11. Tuck in the remaining flap.

12. The finished Pinwheel Envelope!

Designed by David Brill, UK

Dave Brill's Origami Masu

David Brill's origami masu is a marvelous design from many points of view. It is practically a replica of the wooden Japanese sake drinking cup *(masu)*. It was designed to be folded from paper with the proportions of a silver rectangle—a height to width ratio of one to the square root of two—and such paper (letter size is called "A4") is commonly handy in most countries where "A4" format papers are standard. The folding method can be modified to make a masu with three, four, five, six, or even more sides! Brill's is a particularly satisfying masu to fold, and it features several interesting techniques. It is the most challenging model in this book, yet the skills it teaches are well worthwhile. Take your time learning and practicing it and savor its clever design and folding challenges.

For your first experiments with this model I recommend using a larger sheet, so cut a rectangle with a long dimensional length that is easily divisible by five, since you will first need to fold the paper into equal fifths. The length of the short side must make the rectangle agree with the ratio of the silver rectangle. So, if your long dimension is 15 inches (38 cm), the short dimension must be 10⅝ inches (27 cm). Otherwise, use an A4 (letter format) or larger A format sheet. A4 letter paper is common outside of the United States, and it is available even in the US at some office and paper supply shops. You can also follow a simple fold and cut method to convert paper rectangles into "Silver Rectangles." The method is on page 94.

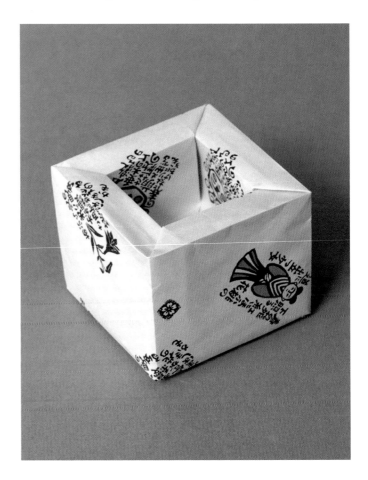

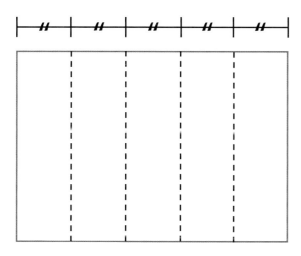

1. Begin inside up. Valley-fold into five equal columns. Refer to page 95 for a clever folding method to accomplish this.

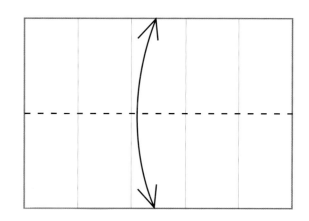

2. Fold in half, long edge to long edge. Unfold.

3. Fold the bottom long edge to the middle crease. Unfold.

4. Install crossing 45 degree angle creases in the bottom row of rectangles. Use the top crease line as your origin. Video note: Use 45 degree creases at this stage of the video, not diagonals.

5. Fold the top long edge down to the level of the intersecting diagonal creases. Unfold.

6. Turn the paper over, left to right.

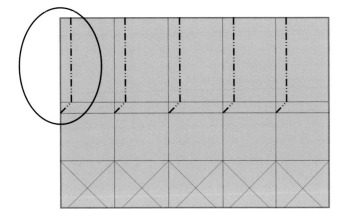

7. Mountain-fold each of the indicated crease sets. Detail to follow.

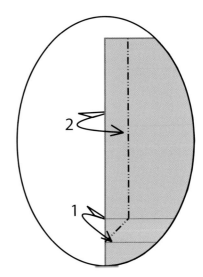

8. Mountain-fold a 45 degree crease between the parallel center creases, then add the vertical mountain crease up from the top end of the 45 degree crease. Unfold after each crease.

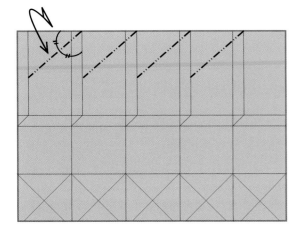

9. Mountain-fold 45 degree creases along the top edge. Note carefully the placement and use the previous creases as a guide.

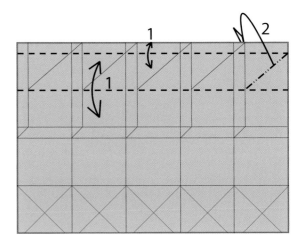

10. Valley-fold and unfold two parallel creases through the intersections at the top and the bottom of the new 45 degree creases. Mountain-fold the final 45 degree crease into the far right rectangular outline.

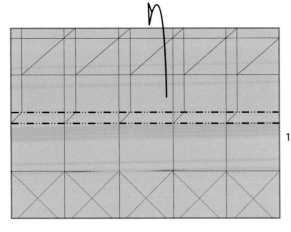

11. Mountain-fold along the two horizontal center creases.

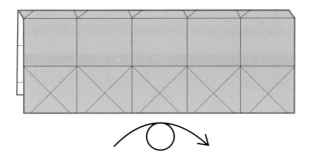

12. Turn the model over, left to right.

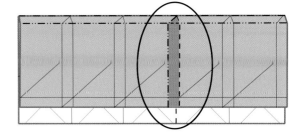

13. Using the indicated creases make a crimp, forming a right angle bend in the model. Detail to follow.

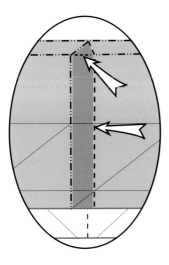

14. Push in at the valley fold lines. The shaded area will move inward.

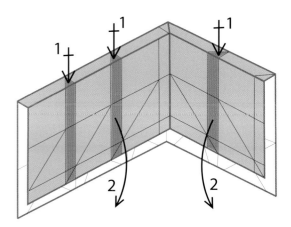

15. Your model should look like this. Unfold the crimp and repeat at each of the three remaining areas indicated by the top arrows (1). Unfold each crimp after completion. All of this pre-creasing will help step 18 move well. Flatten the paper (2). Look ahead to figure 16.

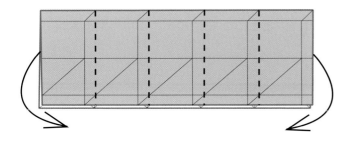

16. Valley-fold at the indicated creases, bringing the left and right ends together.

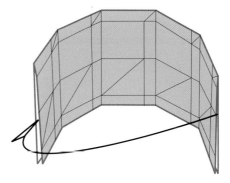

17. Tuck the fifth segment (right end) into the first segment (left end) forming a four-walled, square tube.

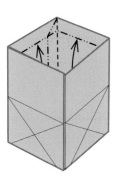

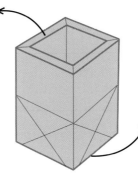

18. Using the crimps that were exercised in steps 14 and 15, push up the inner layers of the tube to 3-D the walls of the masu. Look at figure 19 for the result.

19. Turn the model on its side so that you have access to the bottom end.

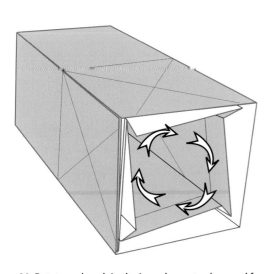

20. Rotate and push in the inner layers to close and form the bottom of the inside of the masu. You must use the diagonal creases to initiate this, but you must also involve all of the other creases in the inner layers in order to form the twist. Make sure that each crease flexes without any kinks or short circuits. Details to follow.

21. Twist in progress.

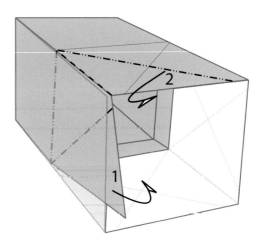

22. Completed twist.

23. Mountain-fold triangle flap 1 inside the model. Mountain-fold the indicated top flap to cover.

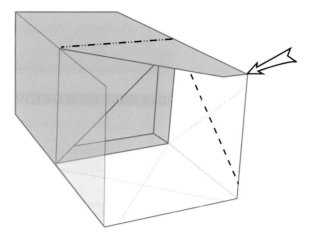

24. Mountain and valley-fold corner layers to cover.

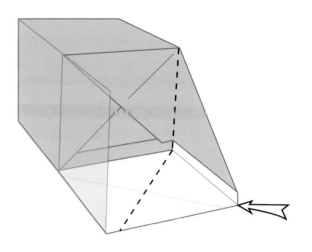

25. Fold in the next corner to cover.

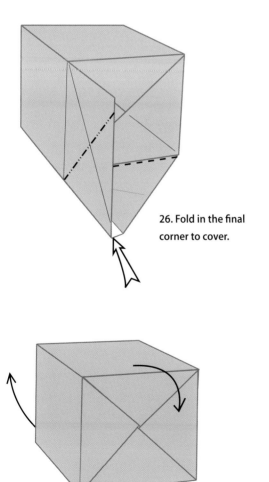

26. Fold in the final corner to cover.

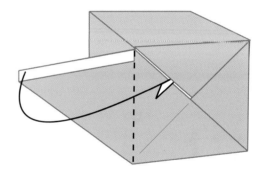

27. Tuck in the indicated triangle flap to lock the bottom closed.

28. Turn the model right side up.

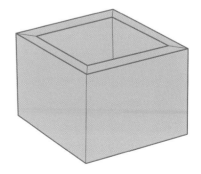

29. David Brill's marvelous Origami Masu.

Suggested Uses for Trash Origami

Many occasions call for a little gift, an acknowledgment, an invitation or a "thank you." Here are some suggestions for using these wonderful origami projects in this book.

FLAPPING BIRD ENVELOPE WITH NOTE & SAILBOAT ENVELOPE

Anytime you receive a gift wrapped in colorful paper, keep the paper! Cut it in convenient squares to fold an envelope for an enclosed Thank You note. Your friend will probably recognize the paper and better appreciate the handmade origami piece you made from it.

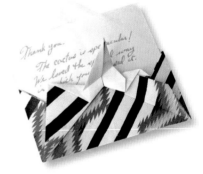

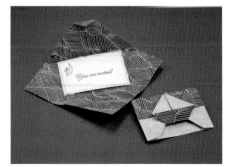

STAR BOX LIDS

Here is a highly decorative, quick and easy multi-piece lid, which is also slightly adjustable to fix any square box.

Square boxes can be easily repurposed using the Star Box Lid. Here, we have wrapped an empty cracker box with some scraps of giftwrap. The Star Box lid was assembled from four folded squares of giftwrap, each measuring 4/3 the length of the box edge. (For example, if box rim is 6 inches (15 cm) on each side, you will need to fold four 8-inch (20 cm) squares. 6 inches x 4/3 = 8 inches.) When assembled, they form a star lid to nicely fit the open end of the box.

Wrap the open box with the giftwrap. Use tape, paste, or a light spritz of spray adhesive to keep it secured. Fold, assemble, and add the lid. Your box is ready to use for a gift or for decorative storage.

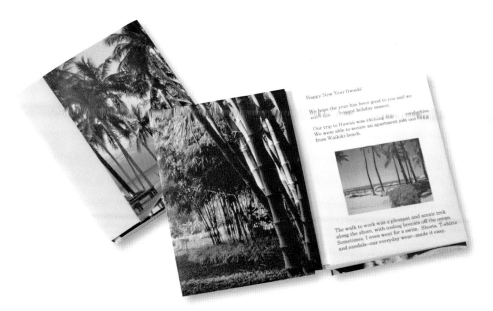

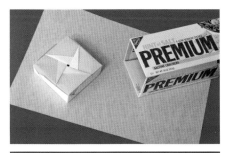

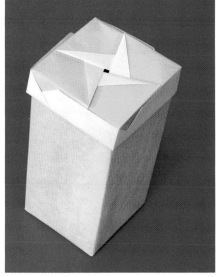

FOLDING BOOKS

Rona's book Is a great project to make your own blank journals, but imagine sending out a custom printed journal of your recent trip or an annual greeting! The following details demonstrate how easy it is to make a memorable keepsake for family and friends. How many times has your printer "wasted" a sheet by printing one word or one line on it? The back is still perfectly clean, so here we have reclaimed sheets of that discarded printer paper, and "bound" it into a folded book with covers from colorful flyers.

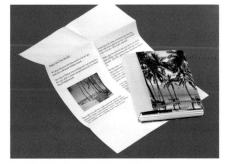

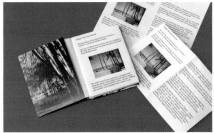

Pre-print the centers of the blank sheets to create a trip journal. This book contains a written account of a sightseeing trip to Hawaii!

Layout your text and photos using a computer application such as Microsoft Word, Apple's Pages, or Adobe Illustrator, and then fold your pre-printed pages as we did.

You can make multiple copies to build as many copies of your customized books as you would like. Send them to friends. These make for a clever and more memorable substitute for greeting cards, postcards or even letters!

TWIST ENVELOPES

For centuries people have used this multi-compartmented locking envelope to keep small or precious things handy. It is sturdy, compact and worthy of memorizing. You will find many clever uses for it. It makes a great wrapper for giving a coin, medallion or other special keepsake. (Pinwheel Envelope, page 82)

1 Once you know how to fold each model, you will see which areas of the paper show. Use this knowledge to allow you to customize any of the projects in this book by printing on the paper before folding, but be careful not to feed your printer any recycled material that may jam or damage it. Here we have used a scrap of giftwrap, trimmed to fit our printer.

The folding crease pattern forms a nine-square grid, which you can create as a template using a computer graphics application. We used some of our origami diagrams for this example, but you can make use of all kinds of information: recipes, photos, riddles or jokes, little-known facts and trivia.

2 Next, install the creases so that the envelope's flaps can be folded to close the model.

3 You can also enclose a small item in the envelope. Here we have included a sample of the origami butterfly explained in the diagrams. Include plant seeds, or tea, a souvenir coin, or perhaps a colorful, commemorative stamp. Make sure the printed text and illustrations relate to the subject you enclose.

4 Fold up the envelope.

5 You will surely have lots of fun coming up with items for a special event, or as travel gifts for your friends.

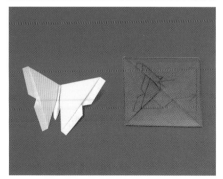

1

2

3

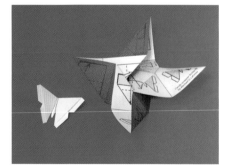

4

5

CUBES

How often have you wasted time, searching for just the right sized box to store, ship, or wrap a gift? Next time, save time by folding this cube project at just the right size! Since folding each element involves only two, simple folds, in less time to find a so-so box, you can fabricate the perfect box—all from small scraps of cardboard. Cutting multiples of the same size rectangles is easy, too! Just stack your cards, and use a straight edge and box cutter to carefully cut through several layers at once. The size is limited only by the size of your source materials. Folding along the corrugations is easy, but for boxes stiff enough to use as furniture, fold across the corrugations by scoring the line first.

Here we have cut scraps of corrugated cardboard and built a large (11inch or 30 cm), sturdy box for shipping sports items. A band of shipping tape around each equator will make sure it arrives intact.

The closed cube is neat and very sturdy.

Gift boxes are easily customized by covering the outer panels with decorative papers, old calendars, dog food bags or related catalog pages! (Cube projects, page 22.)

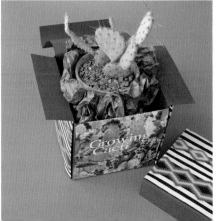

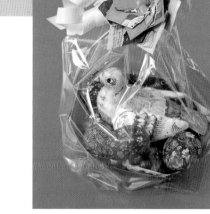

ALI'S FOLDED DISH

This ingenious bowl can be quickly folded from sturdy materials such as card or sheets of plastic, such as acetate, making it a versatile container for many home and gift needs. These can be made quite large, the limit being the size of your folding material.

Gift baskets are a popular way to wrap and present a collection of small but related items. You won't really need baskets if you use Nick Robinson's wonderful origami, "Ali's Dish." (See page 30.) All of the items used to wrap this gift were repurposed from discarded materials.

1 Here we have made "Ali's Dish" from an old calendar page, and the Kite-Lock flower ornament from colorful sales flyers in the Sunday newspaper. The plastic wrapper was from a bouquet of cut flowers.

2 We cut colorful squares of paper from Sunday's newspaper ads to fold and build the flower blossoms. (See "Kite-Lock Flower" project, page 42).

3 We used two sizes of squares: six 3-inch (7.5 cm) squares form the larger; and six 2-inch (5 cm) squares form the smaller blossom. We built two flowers and then secured them with a wire "twist-tie" from a bread wrapper.

4 After rolling a small thickness at one end of the twist-tie, the straight end is threaded through the center holes of the two flowers.

5 The flowers are brought close together, but left slightly apart so that the petals display without flattening. The remnant end of the twist-tie cinches the top of the plastic while securing the flower to the "gift basket."

6 The finished flower.

7 Curl a long strip of colorful scrap paper to add a decoration.

8 Here we have a resourceful and attractive wrapping. Who would have known it was readily made of materials that would have otherwise just gone to waste?

1

2

3
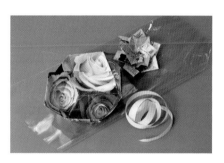

4
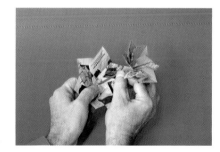

5

6

7

8

THE SILVER RECTANGLE

The International Organization for Standardization (ISO) has defined several paper formats (the A, B & C series of shapes) which are widely used throughout the world. The A-series format is rectangular, with sides based upon the aspect ratio of $1:\sqrt{2}$, also called the Silver Rectangle. The larger side is as long as the length of the diagonal of the largest possible square. One particularly desirable characteristic of paper in this format is that when such a rectangle is divided in half, either way, the resulting, smaller rectangles have adjacent sides with the same proportion as the parent rectangle.

The A-series sheets are cut in specific sizes, and "A4" is perhaps the most common size used by businesses (convenient for letters and computer printer paper). This represents a huge resource for the Trash Origami recycler. Just as designers base some models on the proportions of the US Dollar Bill, many European origami designers such as David Brill, have done extensive work creating origami from this readily available rectangle. Brill's Origami Masu is a marvelous example of the design potential of the Silver Rectangle. Let's explore two essential concepts for the use of this rectangle in the process of constructing the crease pattern for David's Masu.

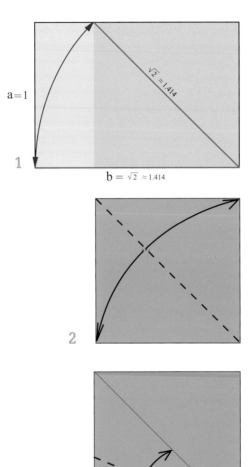

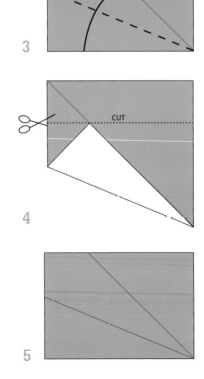

The Silver Rectangle has adjacent side lengths in the proportion of $1:\sqrt{2}$. Since the square root of 2 is about 1.414. When the length of the shorter "edge a" is any value x, the length of this longest edge, "edge b", must be 1.414 times longer than x.

1 The green area of the diagram indicates the largest possible square area that can be produced from the Silver Rectangle. Notice that the length of the square diagonal is equal to the length of the longest edge of the Silver Rectangle. You can imagine how simple it would be to use the length of a particular square, as the short edge, edge a, of a proposed Silver Rectangle, and then take the measure of the diagonal of that square to draw the long edge, edge b. Because this is true, you can also easily determine a Silver Rectangle from a square of paper using the "cut-and-fold" method.

2 Fold in half, corner to corner, and unfold to install a 45-degree diagonal crease line.

3 Fold one edge of the square to the diagonal crease.

4 Cut the paper straight across at the level where the square corner touches the crease line.

5 The largest portion is a Silver Rectangle. This method works because the length of the square will become the longest edge of a Silver rectangle. Using this length to measure an equal length on the 45-degree (diagonal crease line) produces the correct measuring point to set the height of the Silver Rectangle and so the requirement of the specific proportions will be satisfied. You can easily make one of these paper models and use it as a template to describe Silver Rectangles from any scraps, large or small. Lay the template on one corner, and then construct perpendicular lines that intersect any point along the diagonal.

DEDICATION

This book is lovingly dedicated to the memory of our dear friend Florence Temko, one of the true pioneers of paperfolding in the West. Her prolific career designing origami projects, books, and kits for Tuttle Publishing for so many years was an inspiration to us, and we cherish memories of meeting and folding with her at origami conventions. We fondly recall a laughter-filled lunch with her at the Red Lion Inn in West Stockbridge, when she visited Massachusetts one beautiful day.

Florence would certainly applaud the concept of creatively reusing found materials for origami. Her generation lived by the saying, "It's what you do with what you've got!" Turning trash into fun is magic, and origami has always been about making the whole much more than just the sum of its parts. Florence, we all miss you. Our hope is that your elegant designs continue to live on, inspiring and enlightening new generations of folders!

ACKNOWLEDGMENTS

We have enjoyed a long and rewarding relationship with Tuttle Publishing, and on this project we wish to thank William Notte, in particular, for editing our manuscript. His efforts, and the continued interest and support of the entire Tuttle Publishing team, have made this production of projects possible. Our special thanks go to Herman Van Goubergen, Nick Robinson, Rona Gurkewitz, David Brill, Vincent Floderer, and Florence Temko for generously allowing us to bring their joyful origami creations to you. This is our third project for Tuttle that also features video footage of each of the projects, and so we would also like to thank Scott Duval, of EK Media, for his work on the DVD, making the content clear, and the menus easy to understand.

Finally, we thank you, the reader! Your purchase and your continued interest in our long line of origami instructional publications keep us going. We hope you take advantage of a myriad of wonderful materials by giving them a second or third useful life as a folded utilitarian object, or a work of beauty. Perhaps everyone who admires your handiwork will also think twice before discarding attractive and durable foldable materials.

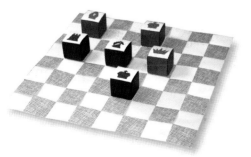

RESOURCES

Here is an international selection of origami web sites and organizations. You will find galleries, instruction, and paper sources, links to other organizations, and inspiration!

David Brill
www.brilliantorigami.com

Nick Robinson
www.nickrobinson.info/origami

British Origami Society
Membership Secretary
Penny Groom
2A The Chestnuts
Countesthorpe,
Leicester
UK
www.britishorigami.info

Centro Diffusione Origami
http://www.origami-cdo.it
Vincent Floderer & Le CRIMP
International Research Center for paper folding.
www.le-crimp.org

Japan Origami Academic Society
c/o Gallery Origami House
1-33-8, Hakusan #216
Bunkyo-ku, Tokyo
113-0001, JAPAN
http://www.origami.gr.jp/

OrigamiUSA
15 West 77 Street
New York, NY 10024-5192
www.origami-usa.org

Origami Organization Directories:
www.origami-usa.org/groups_us
www.origami-usa.org/groups_international

Origamido Studio
www.origamido.com

Dividing A Silver Rectangle Into 5 Equal Sections

It is relatively easy to divide a rectangle of paper into even divisions by folding in half, quarters, etc. Odd divisions can be challenging to make without using measuring tools and arithmetic, but there are several useful concepts and approximations that origami artists use in order to avoid rulers and calculators.

Begin by folding the Silver rectangle in half, long edge to long edge. Unfold.

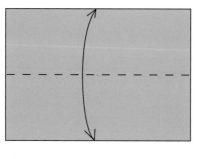

Fold one corner to touch a point on the crease while making a new fold, which intersects the adjacent corner of the common short edge. Unfold.

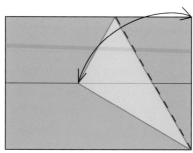

The point where the two creases intersect marks the place where the paper can be folded, perpendicular to the two long edges, delineating a rectangular area 1/5th the area of the full rectangular area.

It follows that the 1/5th area can then be used as a folding factor to further divide the remaining area into equal fifths. One such strategy is illustrated here.

MORE TIPS ABOUT RE-PURPOSING COMMON PAPER MATERIALS:

1. Often paperboard packaging (cereal or cracker boxes) is too thick and brittle for folding without cracking the printed side. After you cut suitable squares, it is easy to remove part of the backing paperboard by pulling it from the printed surface with your fingernails. You may also start it carefully with a knife.

2. Heavier papers, cover stock, index cards, paperboard, and similar materials often fold much more easily with moisture. A light spritz from a plant mister, laying the stock between layers of a moist towel, adding moisture from a steam iron, or keeping them in a sealed sandwich bag overnight with a damp sponge, all work well.

3. Even corrugated paper boxes (cardboard) are suitable when the object is scaled up (made larger). The flap cube folded from cardboard can form interesting pedestals, stands and even kiddie furniture. The flap locking features enable the elements to be joined to form interesting shelves and supports.

4. Flimsy materials, such as candy and fast food sandwich wrappers, can be reinforced with other recovered papers by bonding them with spray adhesive, forming useful laminates. This technique also allows you to make larger sheets out of smaller, less than suitable elements.

5. Metalized plastic bags and wraps are often colorfully printed on the outside and shiny on the inside. While these properties could lend an attractive quality to recycled art, these materials can be too thin and springy for most folding projects without special treatments or techniques. Once again, lamination is a useful technique. Squares cut from similar snack bags can be bonded with spray adhesive and a square of regular, recycled office (computer printer) paper inside. You have the option of making this laminate appear to be metalized silver on both sides, printed on one, or on both sides. The regular paper also lends memory to the folding